NORTHERN KENTUCKY UNIVERSITY

NORTHERN KENTUCKY UNIVERSITY
A PANORAMIC HISTORY
FEATURING THE PHOTOGRAPHS OF THOMAS R. SCHIFF

 UNIVERSITY PRESS OF KENTUCKY

 NORTHERN KENTUCKY UNIVERSITY

The University Press of Kentucky

Scholarly publisher for the Commonwealth, serving Bellarmine University,
Berea College, Centre College of Kentucky, Eastern Kentucky University,
The Filson Historical Society, Georgetown College, Kentucky Historical
Society, Kentucky State University, Morehead State University, Murray
State University, Northern Kentucky University, Transylvania University,
University of Kentucky, University of Louisville, and Western Kentucky
University.

Editorial and Sales Offices: The University Press of Kentucky
663 South Limestone Street, Lexington, Kentucky 40508-4008
www.kentuckypress.com

Library of Congress Cataloging-in-Publication Data

Schiff, Thomas R.
 Northern Kentucky University : a panoramic history /
photographs by Thomas R. Schiff.
 pages cm
 Includes index.
 ISBN 978-0-8131-6562-2 (hardcover : acid-free paper) -- ISBN 978-0-8131-
6588-2 (pdf) -- ISBN 978-0-8131-6587-5 (epub) 1. Northern Kentucky
University--History--Pictorial works. I. Title.
 LD4011.N375S37 2015
 378.769'34--dc23
 2015004373

This book is printed on acid-free paper meeting the requirements of
the American National Standard for Permanence in Paper for Printed
Library Materials.

Printed in Canada.

Member of the Association
of American University Presses

Panoramic Photography by Thomas R. Schiff

Foreword by Geoffrey S. Mearns

Introduction by James Claypool

Essays by Dr. Carole Beere, Dr. Michael Ryan, Dr. Robert K. Wallace,
Dr. Gail Wells, and Dr. Tom Zaniello

Publication Design and Panoramic Image Management by Jacob Drabik

Panoramic Image Production Assistance by Ryan Elliott and Brian Emch

Film Scans for Mr. Schiff by Jeff Siereveld

Archival Photograph Management by Lois Hamill with Vicki Cooper

Project Coordination by Rick Meyers and Kelly L. Martin

Project Management by Ryan Clark

NORTHERN KENTUCKY UNIVERSITY
A PANORAMIC HISTORY FEATURING THE PHOTOGRAPHS OF THOMAS R. SCHIFF

CONTENTS

FOREWORD

In 1968, when Northern Kentucky University was established, our founders considered six different designs for the new crest. While the proposed designs varied in several respects, there was one consistent element: a flame.

A flame has always graced the seal of our university. It represents enlightenment. It symbolizes the collective quest for knowledge, truth, and beauty. That quest continues today.

The flame also symbolizes our appreciation that, within the mind and heart of each student, there is a natural spark of curiosity and desire. At NKU, we embrace a special responsibility to transform that innate spark into a lifelong passion for greater understanding, for a commitment to excellence, and for a desire to serve others.

In that spirit, it is my privilege to present *Northern Kentucky University: A Panoramic History.*

This attractive book celebrates our young history, nearly five decades of innovation in teaching, learning, and placing our students at the center of all we do. In panoramic flair, Tom Schiff, a nationally acclaimed photographer from Cincinnati, uses a special camera to capture the distinctive architecture of our beautiful campus. These photos are paired with older campus images to show the rapid growth of our university.

There are several examples of this progress.

In the early 1970s, NKU comprised a few buildings and small houses. Today we have a modern campus that includes Griffin Hall, the Bank of Kentucky Center, and the James C. and Rachel M. Votruba Student Union.

Four decades ago, our swimming pool was in the backyard of a house on the corner of Johns Hill Road and University Drive. Today we have a state-of-the-art recreation center that is a point of pride for thousands of students and community members.

One final example, among many, of our growth: at the center of our campus was a retaining pond we satirically, yet affectionately, called Lake Inferior. Today, we have Loch Norse, one of many attractive features that grace our beautiful campus.

We created *Northern Kentucky University: A Panoramic History* with several goals in mind. It is our hope that it will help preserve our remarkable past and illustrate how far we've come in a short time. We also see this book as a source of inspiration as NKU embraces a bold and exciting future.

In 2018 our university will celebrate its fiftieth anniversary. We have two paramount aspirations: to empower our students to have fulfilling careers and meaningful lives, and to contribute to the vitality of our metropolitan region.

Each of us has the opportunity and responsibility to contribute to the success of the next fifty years of NKU history. Each one of us can fuel the flame. I hope this book fills you with the same fire and pride that we all share for Northern Kentucky University.

Finally, I invite you to explore ways to become more involved in Northern Kentucky University. Our future is bright, made more so by your active participation in NKU!

Geoffrey S. Mearns
President
Northern Kentucky University

ACKNOWLEDGMENTS

We would like to thank all our contributors. It takes dozens of talented people to complete a project like this.

Tom Schiff and Jacob Drabik (an NKU alumnus) need to be commended—without them, this book would not exist.

Thanks also to NKU President Geoffrey Mearns, Professor Emeritus James Claypool, former Professor Tom Zaniello, Professor Robert Wallace, former Professor W. Michael Ryan, former Associate Provost for Outreach and Dean of Graduate Studies Carole Beere, and former Vice President for Academic Affairs and Provost Gail Wells for their essays and memories of past presidents.

We are indebted to the NKU Eva G. Farris Special Collections and Schlachter University Archives staff, especially Lois Hamill and Vicki Cooper, for their constant direction and input, especially when providing and identifying archival photos.

To Ryan Clark, and other select members of the NKU Marketing and Communications staff (especially Rick Meyers and Terry Boehmker), thank you for steering the ship and providing extra eyes on every page.

Many thanks to NKU photographer Tim Sofranko, former NKU photographers Joe Ruh and Joe Munson, and NKU web editor Alex Lytle for their additional images.

Lastly, to Ashley Runyon and everyone at the University Press of Kentucky, thank you for showing us the way.

Editor's Note: We would be remiss not to mention the efforts of two other men who contributed to the growth and development of NKU. Ralph Tesseneer was the interim president from 1975 until 1976, and Jack M. Moreland was the interim president from 1996 until 1997. We are grateful for their service and leadership.

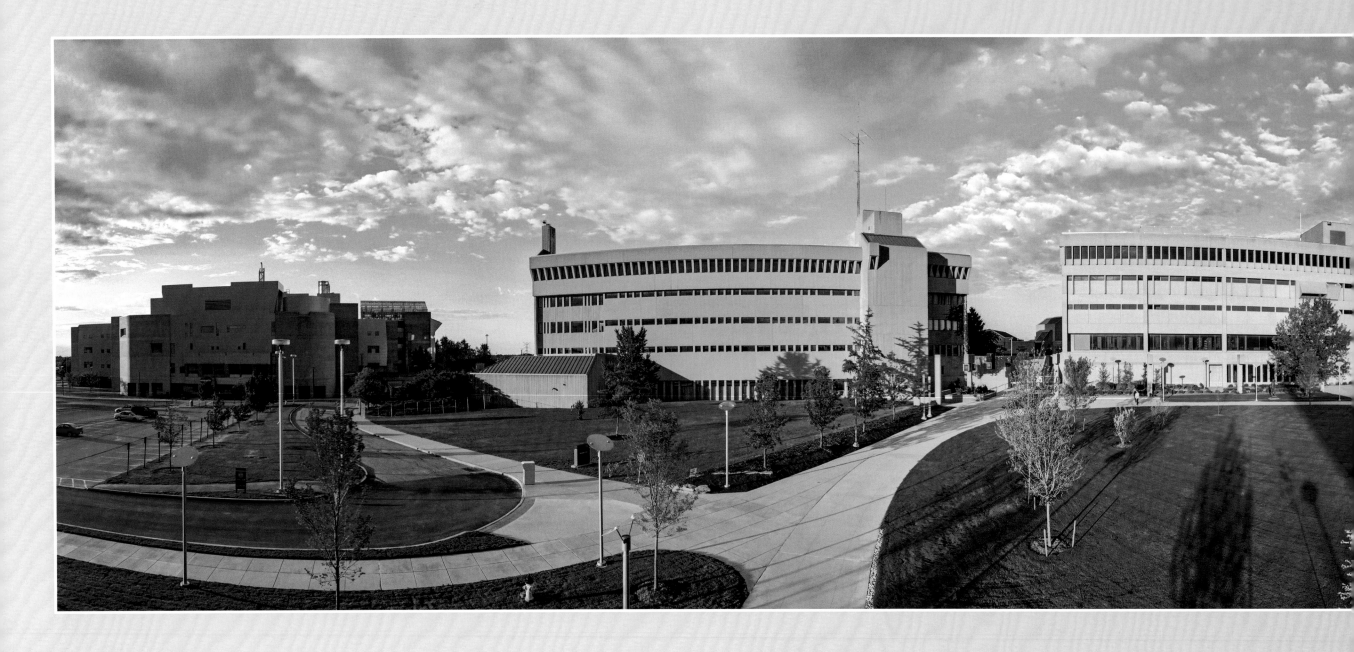

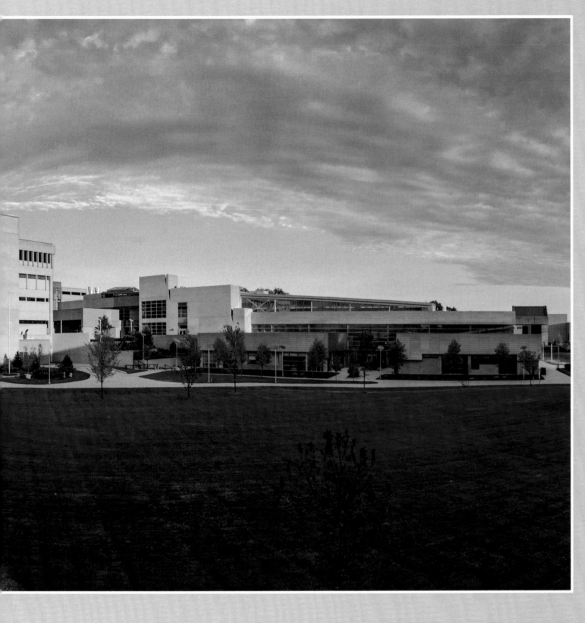

Northern Kentucky University campus, shortly after sunrise, 2010

WHAT IS PANORAMIC PHOTOGRAPHY?

Thomas R. Schiff specializes in panoramic photography. Each of Schiff's photographs shows a 360-degree area (and sometimes even more than that) in a two-dimensional view. Because of this technique, some of the photos look a bit different from the actual sites. Schiff has said that if the prints were large enough, the photo could be wrapped around the viewer to create a miniature model of the space.

Schiff has produced panoramic books about Las Vegas, Cincinnati, the state of Ohio, and Frank Lloyd Wright's architecture. Schiff's work has been featured in galleries and museums around the world.

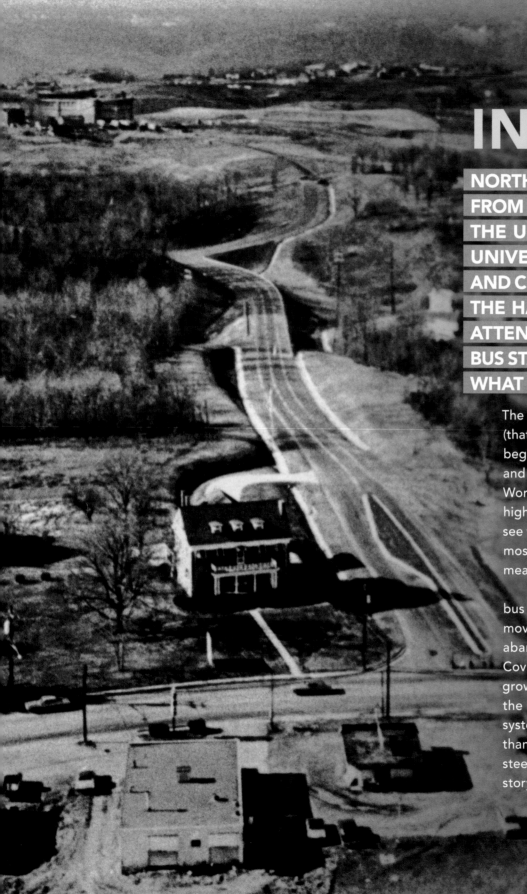

INTRODUCTION

by James Claypool

NORTHERN KENTUCKY UNIVERSITY'S EVOLUTION FROM AN EDUCATIONAL EXTENSION BRANCH OF THE UNIVERSITY OF KENTUCKY INTO A MAJOR UNIVERSITY IS A STORY THAT STIRS THE HEART AND CHALLENGES THE IMAGINATION. HOW COULD THE HANDFUL OF STUDENTS AND INSTRUCTORS ATTENDING CLASSES IN 1946 AT THE TRAILWAYS BUS STATION IN COVINGTON HAVE EVER IMAGINED WHAT THE NEXT SEVEN DECADES WOULD BRING?

The University of Kentucky's educational extension services (that was what these programs were called in 1946) offered beginning math, typing, first-year business courses, English, and little else. In general, the student body was a mix of World War II veterans on the GI Bill, secretaries, and recent high school graduates, many of whom were just there to see what college was all about. And the instructors, for the most part, were local high school teachers moonlighting for meager wages.

Despite such humble beginnings, it worked. The bus station's facilities were quickly outgrown, and classes moved in 1948 to Covington's First District School, a site abandoned in 1961 for a hillside campus overlooking Covington, the new home of the University of Kentucky's growth-oriented Northern Community College. This was the first community college in UK's community college system and the pacesetter in enrollment, and by 1968 more than a thousand students were taking classes in the two steel-structured buildings on campus. The next part of the story involves politics.

A study conducted in 1961 had found that northern Kentucky was the most populated area in America in which there was no four-year public institution of higher education. Suddenly the stars were aligned to change that. In 1967 Kentucky elected Louie B. Nunn governor, the first Republican to win that office in twenty years. Nunn credited his victory to his unusually strong showing in northern Kentucky, a political trend he hoped Republicans could cultivate and expand. A hike in the state sales tax (dubbed "Nunn's Nickel") and some intense lobbying from a bipartisan group of prominent northern Kentuckians paved the way for the legislative bill passed in 1967 and signed by the governor that created Northern Kentucky State College, Kentucky's seventh four-year public institution of higher learning. The bill provided for the purchase of the University of Kentucky's hillside campus in Covington, for absorbing its faculty and staff, for the appointment of a governing board, and for staffing the new college. What it did not provide was funds to do this. Consequently, it would be three years, until July 1, 1970, before the new college actually took over from the community college and began operations. Moreover, the University of Louisville, a city college with a large base of employees and a sizable and expensive campus to maintain, simultaneously entered the state system, an event likely to have a negative effect on funding for the new college.

Undaunted, the Board of Regents of the new college hired Frank Steely as president, shrugging off complaints that Louie Nunn was being asked to accept a lifelong Democrat as "his school's" first president. Nunn was quick to point out that political fortunes, and governors, change in Kentucky

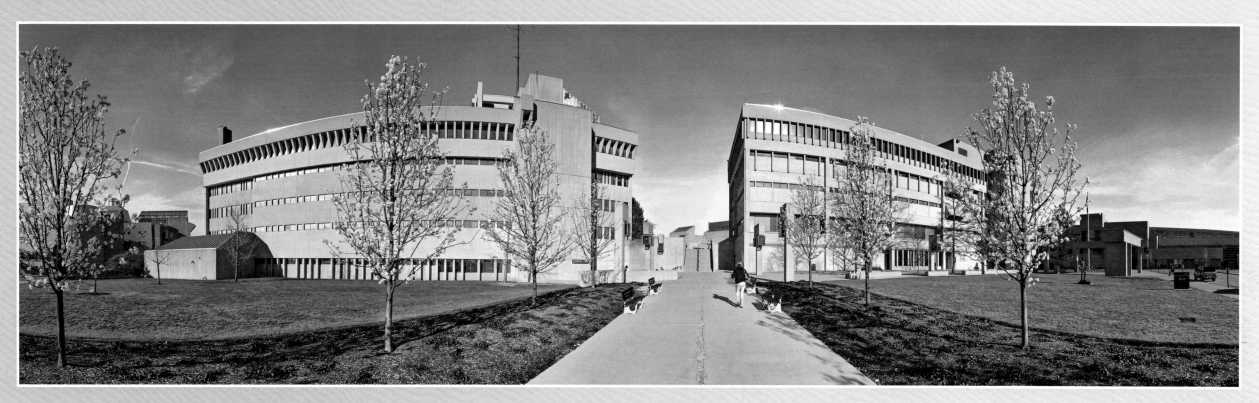

Above: Founders and Nunn halls, 2010

Previous page: Early campus construction, circa spring 1972

and that Northern Kentucky State College belonged to the community, not to him. Steely hired a skeleton staff consisting of James Claypool, dean of admissions, who arrived February 1, 1970, ten weeks in advance of Steely; Ralph Tesseneer, academic vice president; John Kilkenny, budget director; John DeMarcus, vice president of administration; and two secretaries. The new NKSC administrative staff was derisively labeled "the magnificent seven" by a group of the community college's employees who were upset over losing their UK basketball ticket rights.

It would not have been easy to predict how northern Kentucky would begin to rally behind the news and how exponentially the community's support and pride in the new school would grow. This pride has played out in community support for the institution's fight for adequate funding, in its support of the need to build new buildings and classrooms,

and in its recognition that Northern Kentucky University has grown into a truly cosmopolitan university that offers what once would have seemed a mind-boggling array of educational opportunities.

Trying to ascribe credit to any one individual for the university's remarkable growth and development would be a mistake. Still, one way to understand and evaluate it all is to look at what was accomplished under each of the university's seven presidents and to comment on their leadership skills, their personalities, and their achievements while remembering that none of this could have been accomplished without considerable help and the infectious enthusiasm of the thousands of individuals associated with NKU and its history.

Frank Steely was Northern Kentucky State College's first president. Born and raised in western Kentucky, Steely had advanced degrees in American diplomatic history from

the universities of Kentucky and Rochester, taught and was a department head at Murray State University, and had just helped take a two-year college at Clinch, Virginia, to four-year status. Not a physically large man, Steely made up for his lack of size with pluck. He relished the fray, believed everything should and could be won in debate, and never left anyone attacking the new college unchallenged or unscathed. His love-hate relationship with Vance Trimble, the editor of the *Kentucky Post*, was legendary. One day the paper would praise Steely; the next it would attack him.

The accomplishments of the Steely years, 1970–75, were extraordinary. Enrollment during these years grew from 1,662 to more than 6,000; the school moved to its new 328-acre campus in Highland Heights; four buildings, Nunn and Regents halls, the first science building (now Founders Hall), and the Steely Library, were built; the budget increased

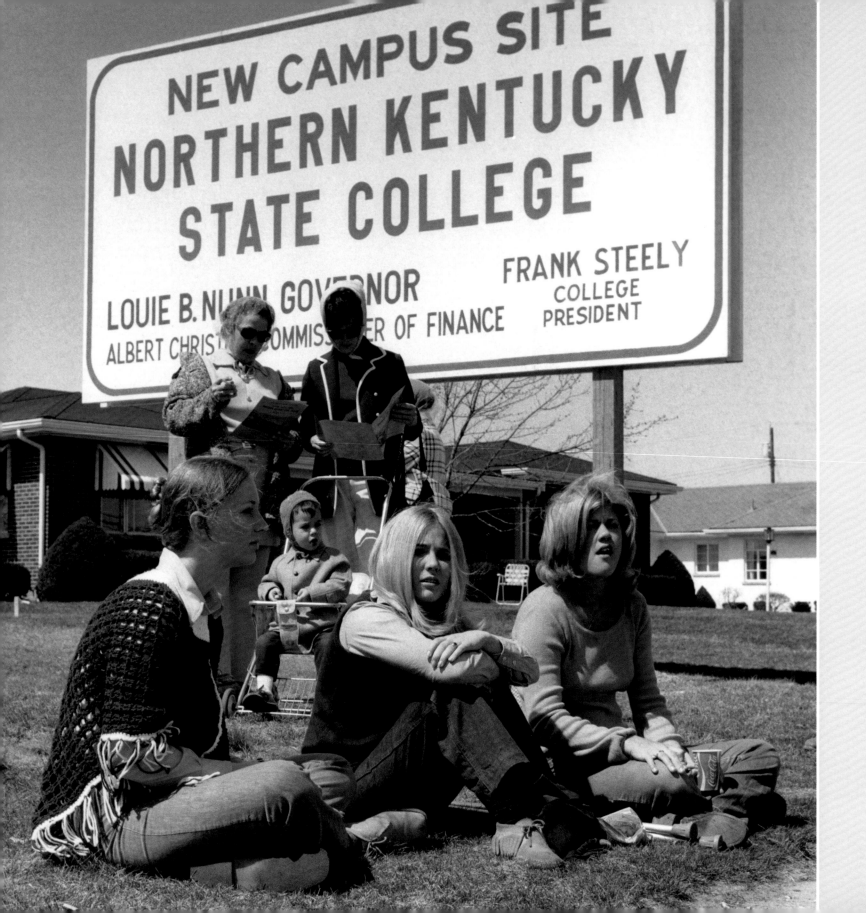

substantially; Chase College of Law merged into Northern; and the first commencement exercises were held in spring 1973 with nearly seven hundred graduates. By 1975 NKU had forty-six academic majors, more than fifty student organizations, a men's and women's intercollegiate athletics program, a radio station, an award-winning student newspaper, a cheerleading squad, a drill team to perform at basketball games, many distinguished graduates, a nationally and internationally recognized faculty, and the sense that we belonged.

Steely stepped down as president in September 1975 and taught history at the university until illness forced him to retire. He was often seen strolling across the campus, chewing on his trademark cigar, a man justly proud of what he had accomplished. One of Steely's top confidants, Ralph Tesseneer, who as vice president of academic affairs was the chief architect of the school's amazing academic development, was appointed interim president after Steely relinquished the presidency. Tesseneer, like a number of other administrators at Northern, had been at Murray State University, where he had taught psychology and later served as a graduate dean. So many of the early administrative people had ties to Murray (including this author) that they were soon being referred to, seriously and in fun, as "the Murray Mafia."

Although his style was different, Tesseneer showed himself to be a man of action and purpose. Raised in Alabama, with the appropriate slow southern drawl, and someone, as the old saw goes, "who never met a stranger," Tesseneer continued the good fight, just in a less confrontational manner. His strong point was "his people skills," and he used these effectively in Frankfort to lobby to increase the university's budget and later, as head of the university's nonprofit founda-

Spectators at the campus groundbreaking ceremony, March 31, 1971

tion, to raise considerable sums from private sources. He also gave the faculty and staff the largest percentage raises they had received to that date. And on June 19, 1976, while Tesseneer was serving as interim president, the college became a university.

Many traditions were well established at Northern by the time Tesseneer took office. The school had an alma mater song; the lamp of learning was its symbol; the school had colors (gold and white with black trim); the fight song had been written; and students had voted to make Norsemen (later changed to the gender-neutral term Norse) the official nickname. These were fun and exciting times for the ever-expanding student body, which by fall 1976 totaled more than 6,400. Moreover, the student body was at that time being drawn from throughout Kentucky as well as from other states and countries. Students, too, were beginning to shed the commuter mentality that had once prevailed and were becoming increasingly involved on campus. By vote, students had mirthfully named the small pond on the edge of campus Lake Inferior, and a carnival-like celebration known as the Rites of Spring had been established as an annual event.

In July 1976 A. D. Albright, head of Kentucky's Council of Higher Education, became the university's second president. Politically astute and well connected, Albright, who at age sixty-four had more than thirty years of experience in higher education as an administrator, brought a fatherly presence to the presidency. Albright had actually been the first person offered the school's presidency in 1969 but instead accepted a Fulbright Fellowship to study in Belgium. Albright was cautious, meticulous, and shrewd. He quickly won support among faculty, staff, and students by listening to their views and promising to consider finding solutions to their concerns. He also was popular with the Board of Regents. These, however, were stringent times in Kentucky, and Albright adopted the tactic that Northern, which was still greatly underfunded, should not press the issue as much as his predecessors had. He reasoned, with some success, that it was better to draw on his own stature in the state to acquire funding than to do open battle with other university presidents. Another tactic he employed was to have major issues studied by multiple committees, which allowed him to select recommendations that were consistent with his aims. All this was quite effective, as Albright continued to be very much liked and well received by those both at the university and in the community during the seven years, 1976–83, he was president.

The Albright years saw a number of significant changes:
- Yet another growth spurt in enrollment
- Expansion of academic programs
- Establishment of the university's foundation, headed by Ralph Tesseneer
- Completion of five new academic buildings—Landrum Academic Center in 1976, Fine Arts Center in 1977, University Center in 1977, Business-Education-Psychology Center in 1980, and Lucas Administrative Center in 1982 (the Albright Health Center groundbreaking was in 1982, during his tenure, but it didn't open until 1984)
- Completion of two new residential buildings (Commonwealth and Kentucky halls in 1982)
- Creation of a technical and small-business development park on the edge of campus

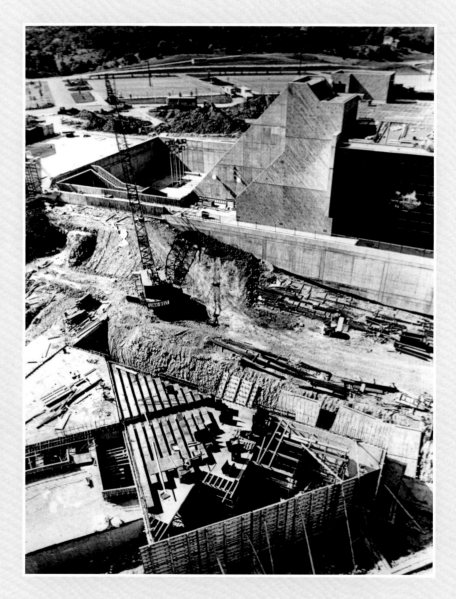

Construction of the Steely Library and the Fine Arts Center, 1975

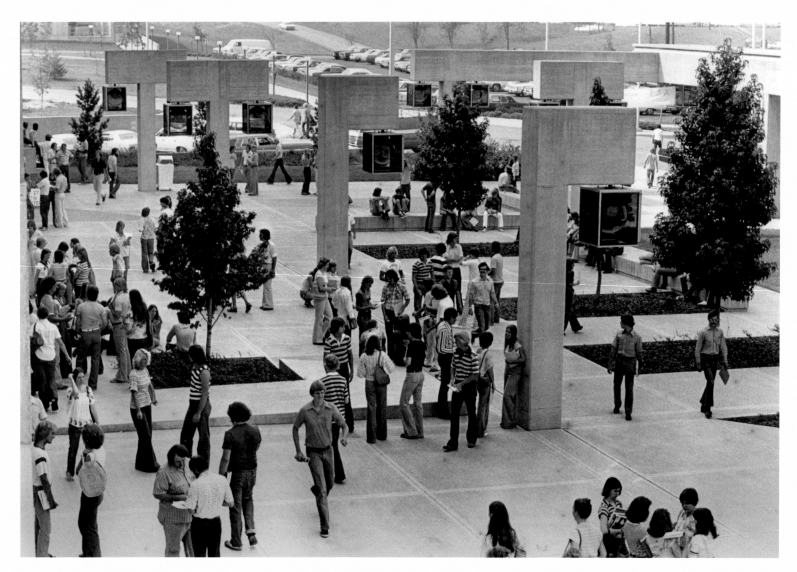

First day of classes, 1976

- Expanded enrollment at Chase College of Law (successfully intended to draw students from throughout Kentucky while cutting out-of-state enrollment)
- Concessions to the economic realities in Kentucky that kept spending carefully monitored

The decision to focus on admitting Kentucky residents to Chase College of Law, which moved from the Covington campus to Nunn Hall in 1982, was particularly astute, as it both blunted criticism that the college had too many out-of-state students and provided a pool of influential lawyers and judges, in Kentucky and elsewhere, who were alums of NKU.

Albright announced his retirement in October 1982, and six months later the historian Leon E. Boothe was tapped to become NKU's third president. Boothe, who in December 1976 had applied for the position of chief academic officer at Northern but lost out after making the final five, came to the university from Illinois State University, where he had been vice president and provost. He was inaugurated in December 1983. The Board of Regents instructed Boothe to focus on expanding the university's presence nationally and internationally and to increase diversity, tasks that would remain the new executive's top priority. Boothe set about meeting these challenges with great energy. He made frequent trips abroad; joined a plethora of regional boards; encouraged recruitment of minority students; gave priority to staff, faculty, and administrative job applications from minorities; and made countless public appearances in the region, state, and world on behalf of the university.

In 1987 a baseball field was built that would later be named Bill Aker Baseball Complex at Friendship Field, in

honor of the school's legendary first baseball coach. Later, in January 2013, Aker, who had died in 2011, became the first intercollegiate coach at Northern to be inducted into a national hall of fame. Construction of the baseball field in 1987 caused speculation that Northern was considering moving from Division II competition to Division I, but Regents Hall, the school's sports and events arena, was too small to consider seriously such a move at the time. The university did, however, begin to lobby Frankfort for funds to construct a new sports and convocation center, but the idea was forced into the background by other pressing budget needs. The issue would resurface in 1990, while Boothe was still president, only to be set aside again because of political infighting in the legislature. Finally, in 2004 Governor Ernie Fletcher (the first Republican governor since Louie Nunn) leveraged the Republican Party's legislative strength in northern Kentucky to include $42 million in his budget to build a regional special events center at NKU, subsequently named the Bank of Kentucky Center.

By spring 1990 Northern's enrollment had surpassed 11,000, and classrooms often filled to capacity. Some of these problems were alleviated when the new Applied Science and Technology Center (now the Business Academic Center), with its modern classrooms and large computer lab facilities, opened later that semester. The Fine Arts Center was also modernized and expanded in 1992 with the addition of Greaves Concert Hall. By this time, the university's Fine Arts Department was recognized throughout the region and even nationwide for its high-quality musical programs and theater productions. Many graduates in these disciplines have gone on to successful performing careers, and one NKU student

of the 1970s, who did not stay around to graduate, George Clooney, remains one of the world's top movie box-office attractions.

President Boothe shepherded NKU through a period of noteworthy growth and achievements, including the opening of a number of nonacademic buildings: Albright Health Center opened in 1984, and three new facilities for students living on campus were dedicated in 1992: Woodcrest Apartments, Norse Commons, and Norse Hall. The upsurge in enrollment during his tenure saw an expansion of programs and offerings at the university, increases in the size of the faculty and staff that caused NKU to be recognized as one of the region's major employers, and a growing sense of community within the university that saw its student body, once primarily regional in nature, now diversified and drawn from schools nationwide and from countries far distant. Boothe resigned his presidency in 1996 and remained to teach history until his retirement in 2007.

He was replaced by Jack Moreland, a personable local high school superintendent who served as interim president for part of 1997. Moreland, who had helped lead the political and legal battle to see that small, underfunded school districts in Kentucky were treated fairly in the Kentucky Educational Reform act of 1990, stood in capably and even stirred up some spirited controversy when he announced his support for a football program, an idea rejected by the Athletic Committee.

Enter the Votruba era. James Votruba was inaugurated as NKU's fourth president on August 1, 1997. He brought with him from his teaching post at Michigan State a master plan for the future that he termed Vision, Values, and Voices,

Students taking a break, circa 1977

the three principles that best describe his fifteen-year service (1997–2012) as president. Sophisticated, thoughtful, and highly engaged, Votruba led the university to attain new levels of respect. He quickly mastered the political nuances of getting increased funding from Frankfort; reached out to the community for support and funds; was engaged, along with others from the university, in high-profile civic endeavors; and gained a national reputation as a leader in the field of higher education, thereby helping put Northern "on the educational map," so to speak.

Both the university's curriculum and its physical plant grew markedly during the Votruba years. NKU currently offers

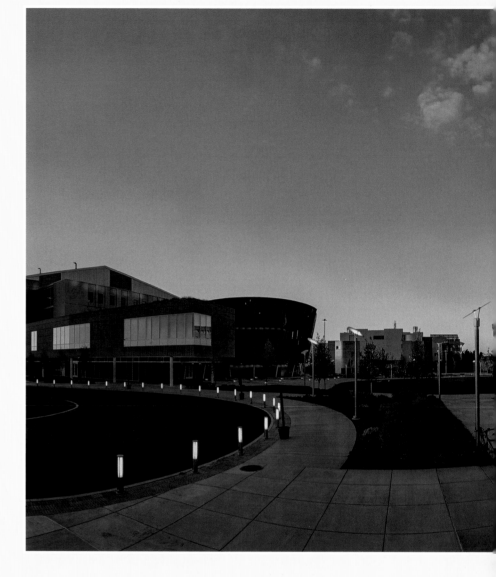

Left: The original Student Union, 1972

Right: James C. and Rachel M. Votruba Student Union, 2011

more than seventy bachelor's degrees and twenty master's programs, two law degrees, and two doctorates. New ideas for cutting-edge programs to add to the College of Informatics (2011) were plentiful and innovative. Facilities added during Votruba's tenure include the $38 million Dorothy Westerman Herrmann Natural Science Center (2002); an expansion of student housing, newly constructed University Suites (2003) and the renovated Lakeside Manor building, renamed Callahan Hall, after James Callahan (2008); the $40 million Student Union (2008) (now the James C. and Rachel M. Votruba Student Union); the Bank of Kentucky Center (2008); Soccer Stadium (2010); Griffin Hall (2011); and two off-campus facilities, the NKU Grant County Center (1998) and the METS Center (2003), a training and learning complex for local business leaders. Two other significant events before Votruba transitioned in 2012 from being president to teaching were Highland Heights' annexation of Northern's campus in 2008 and the Carol Ann and Ralph V. Haile, Jr./U.S.Bank Foundation's $15 million donation to the College of Business, the university's largest single donation by private individuals.

Exciting times are on the horizon for NKU and its more than 15,000 students. The institution's fifth president, Geoffrey Mearns, is hard at work. In an address delivered to the university at the opening of the fall semester in 2012, Mearns, who was a prosecuting attorney at the trial of the Oklahoma City bomber Terry Nichols, and provost (and dean of the law school) at Cleveland State University, outlined his thoughts about the future. Focusing on how to define and quantify student success, Mearns announced plans to implement a number of initiatives in the area of student affairs, including creating the Student Success Center, to proactively assist students needing help to succeed academically, and using technology to track the success of these initiatives. These plans are reminiscent of a motto from earlier years at NKU that proclaimed, "At NKU we put students first."

The résumés of all those associated with NKU and its history are extensive and impressive. The list of achievements of its administrators, faculty, and staff would fill many volumes. Its athletics program, now transitioning to Division I, has won three national titles and numerous conference cham-

pionships, and the GPAs of student-athletes are consistently well above the overall university average. The university's law school graduates occupy law offices and courtrooms near and far. Its Board of Regents has included bankers, attorneys, civic leaders, philanthropists, business leaders, medical practitioners, internationally acclaimed architects, a congressman, and some of the most influential leaders from the region and

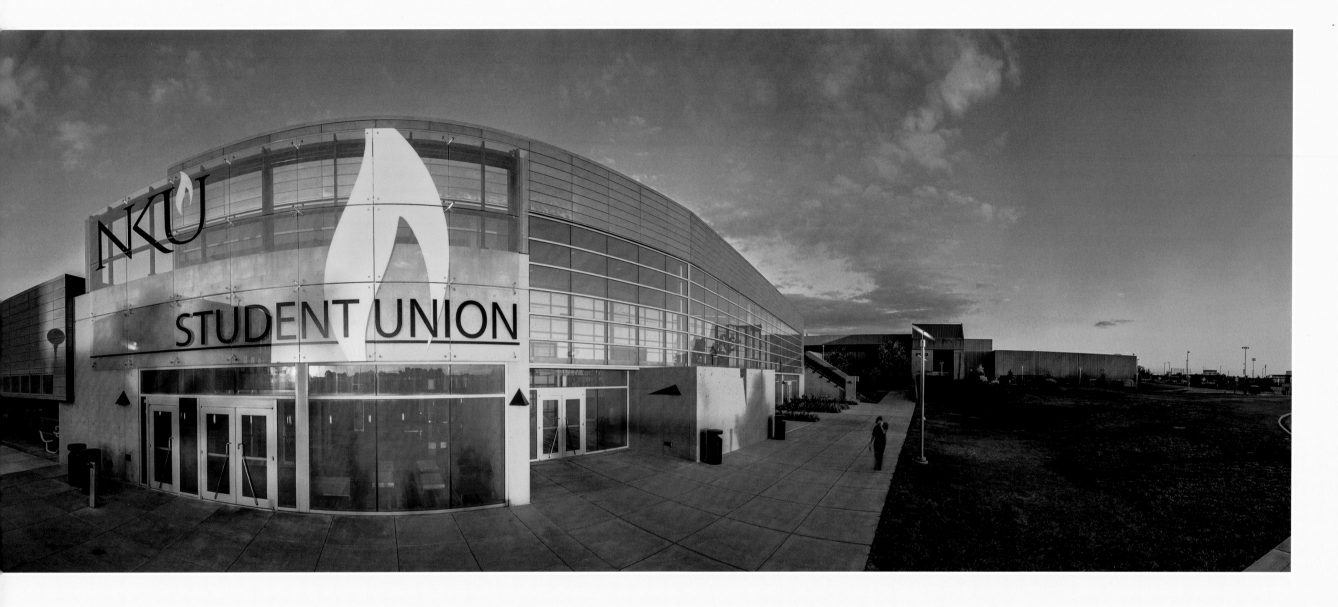

the state. A degree from NKU means something. The institution's graduates, large numbers of whom have remained in the region, are sought-after and highly productive workers. These NKU alumni form the fabric of their communities and are engaged in an array of civic-minded and charitable activities all the while living normal lives, pursuing their individual dreams, and raising families.

All great success stories are related to the sum of all their parts—Northern Kentucky University's story of success is no exception.

James Claypool is professor emeritus in the Department of History at NKU. He served as the first dean of admissions and students and spent thirty-four years at NKU as a teacher and administrator.

9

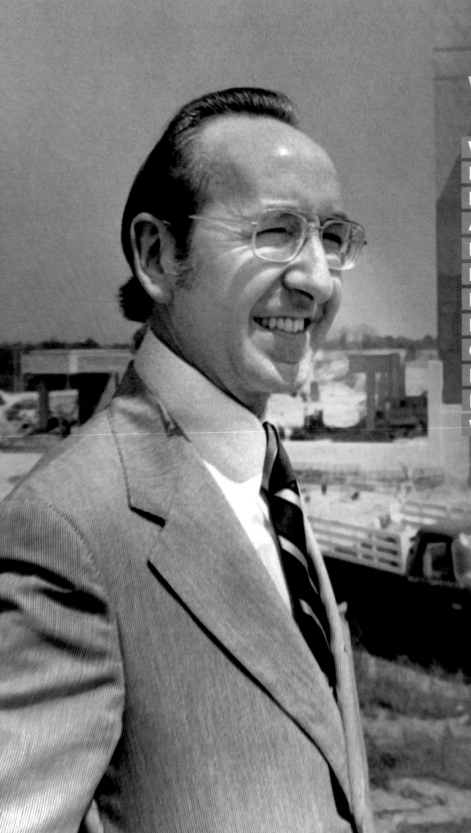

W. FRANK STEELY, 1970–1975

by Tom Zaniello

WHAT WE NOW PROUDLY CALL NORTHERN KENTUCKY UNIVERSITY, PARADOXICALLY, HAD MORE THAN ONE CAMPUS WHEN I ARRIVED AT NORTHERN KENTUCKY STATE COLLEGE IN HIGHLAND HEIGHTS AS A NEW ASSISTANT PROFESSOR IN 1972. I WAS PART OF A SMALL ARMY, PERHAPS MORE THAN FIFTY STRONG, OF YOUNG PROFESSORS, A FAIR NUMBER JUST OUT OF GRADUATE SCHOOL AND NOT MUCH OLDER THAN MANY OF OUR NONTRADITIONAL STUDENTS, MOST OF WHOM HAD ALREADY STARTED AT WHAT WE NICKNAMED "THE COVINGTON CAMPUS."

I was not yet thirty years old, although I had been teaching elsewhere for three years.

Could there really have been three campuses? Yes, let us start with the original home of the college, the Covington campus on the hill, now no longer active, but then a wonderful location with panoramic views of the area. It became home to the Chase College of Law, added to NKSC's crown in a brilliant campaign led by W. Frank Steely, the college's first president, and ratified by Campbell County Circuit Court Judge Frederick M. Warren, who said the law school was a bargain for, not a liability to, the college. Kentucky Attorney General Ed Hancock approved the merger. A good-sized handful of undergraduate classes were held at this campus, and some programs were run here for years.

But there were also two campuses in Highland Heights. Once consisted of two new buildings, Regents Hall (also known as the gym) and Nunn Hall (with its faculty, staff, and administration offices), as well as the library, a small auditorium, and a student lounge.

The "other" campus consisted of the numerous buildings not demolished on the Highland Heights site that had been part of the old Studer Farm as well as those on the neighboring local streets. And part of the success of President Steely's leadership team was to make use of that intriguing variety of buildings still available in those early days:

- The basement of a house on Johns Hill Road became the Early Childhood Center, filled up with the offspring of the new, young faculty.
- The basement of another was converted into a small snack bar next to Studer Pond (now refurbished as Loch Norse), the location of a famous bathtub boat race. One of the captains, sporting a sailor's cap, was the resourceful new president.
- The President's House eventually became—and still is—the home of the Honors Program after the brief stay there of our fourth president, James Votruba, who was often greeted on his balcony in the morning by students heading off to the woods behind the house for biology field trips.

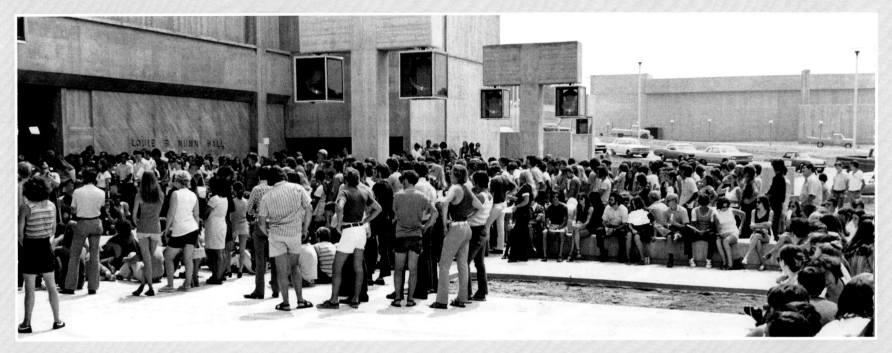

Students crowded outside Nunn Hall, 1972

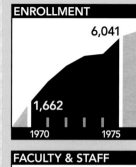

ENROLLMENT

6,041

1,662

1970 1975

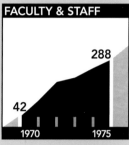

FACULTY & STAFF

288

42

1970 1975

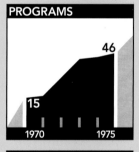

PROGRAMS

46

15

1970 1975

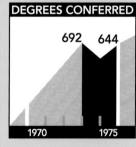

DEGREES CONFERRED

692 644

1970 1975

The President's House is curiously named: John DeMarcus, the first administrative vice president, lived there. Steely preferred a split-level home in nearby Ft. Thomas.

• The pottery barn was where the ceramicists ruled for years, until they got a brand-new building opposite University Suites.

• One of the Studer farmhouses housed the photography instructors, and musicians practiced in another building, an old kennel, where dogs used to howl.

• The house where the math department was located was my favorite because it had a ping pong table in the two-car garage.

They gave us the sense of simultaneous hope for the future and amusement at our sense of working in a slightly upscale relocation camp.

Since we could park virtually anywhere in those days, the two sets of buildings were easily accessible. I think we all had sufficient faith in Steely's leadership at that point and DeMarcus's downstate savvy (his father had been speaker of the house in Frankfort) to believe we would one day have a real, integrated campus.

Even if we had to imagine ourselves in that future, for the most part the vision for a major state university was already in place in the 1970s, though the specifics took almost thirty years to be realized.

Steely's career at NKSC really began on the Covington campus soon after he was hired in 1969 and he had to secure the college's first budget from the legislature in Frankfort. This endeavor was a harbinger of many budget struggles in which Steely and later presidents would learn the art of wheeling and dealing. Once established in Covington, Steely and his administrative team began the process of transforming the Studer Farm into a college, starting from scratch.

Within two years the Highland Heights campus was up and running, and the college held its first graduation in May 1973, truly a remarkable moment in its history. Steely's pride was contagious as the faculty marched in to their first NKSC graduation ceremony in Regents Hall. Having received its conditional accreditation from the Southern Association of Colleges and Schools, NKSC was already demonstrating how quickly it could move into major college status. Full accreditation came in December 1978, after Steely had returned to the faculty in 1975.

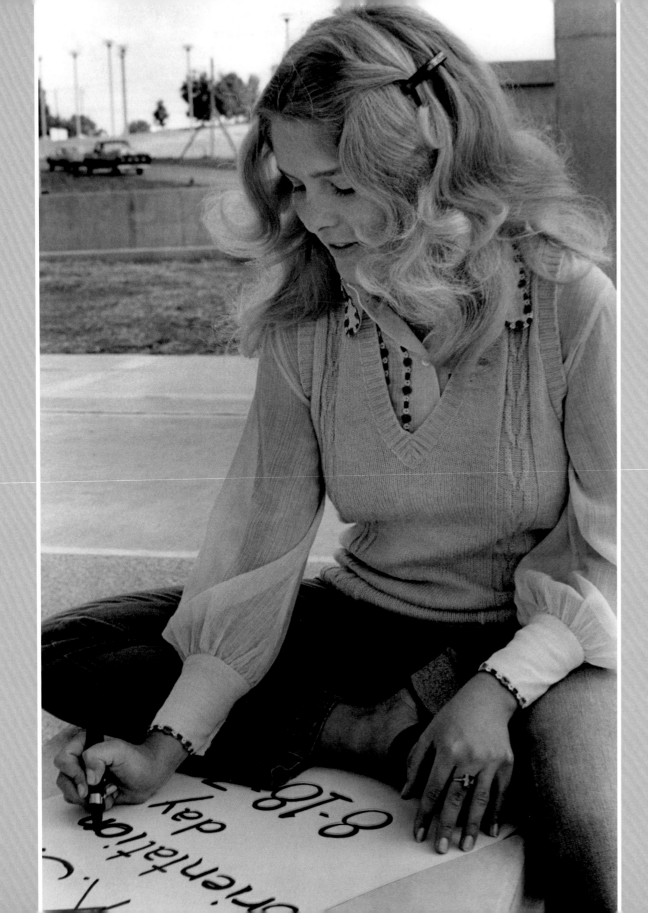

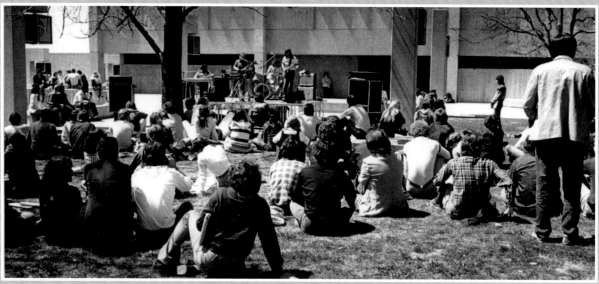

Above: Students enjoying a concert outside Nunn Hall, 1970s

Left: A student making a sign for orientation day, August 1972

Not perhaps particularly visible to the students, but an essential building block of Steely's tenure, was the creation of the NKSC Research and Development Foundation in the fall of 1970. This unit grew into what we now call the NKU Foundation, an essential financial linchpin of the university, thanks to its fund-raising, grant-raising, and grant-making activities as well as its support of scholarship programs.

Gradually the "other" campus was replaced, during Steely's years and afterward, by a substantial complex of new academic buildings, residence halls, ball fields, parking lots, and all the other pieces of infrastructure that transformed a state college into a university community.

President James Votruba, who in 2012 retired from presiding over our major metropolitan university, comprising more than 15,000 students and 2,000 faculty and staff, understood Steely's early successes: "Frank Steely's greatest early achievement may have been his knack for hiring staff,

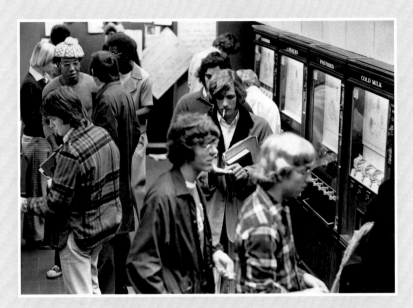

Vending machines in Nunn Hall served as a cafeteria, early 1970s

Students socializing in front of Founders Hall, 1970s

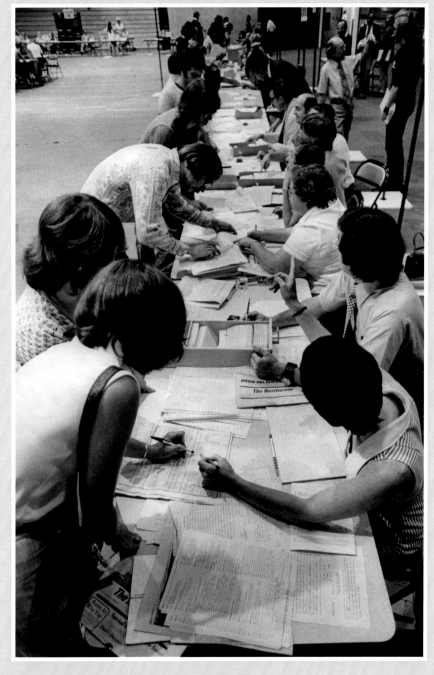

Open registration in Regents Hall, early 1970s

faculty, and administrators who believed in the future of the university. Much of what our campus is today and will be tomorrow can be traced to the work of these very special men and women."

Now that the bustling campus of the twenty-first century is filled with impressive residence halls, the new Griffin Hall and its George and Ellen Rieveschl Digitorium, and the James C. and Rachel M. Votruba Student Union, not to mention the Dorothy Westerman Herrmann Natural Science Center, it is hard to imagine the Highland Heights campus in the early 1970s. With the majority of faculty and classes as well as the entire administrative team in one building, Nunn Hall, our campus and academic life in the 1970s might have seemed circumscribed. But we knew each other's business in those days, and the synergy of close contact with other departments meant that faculty could rub shoulders and minds across the disciplines, preparing for such later movements

as "writing across the disciplines" in the 1980s and the "learning communities" that were pioneered at NKU in the 1990s for facilitating students' success and cooperation among the faculty.

In our very first year at NKSC, when Frank Steely heard about efforts we were making in the English Department to improve student writing, and when a group of us from a couple of departments started the first film society and launched a film series on campus, we were encouraged in our efforts to propel our fledgling college into the future. We were decentralized enough in those days to realize that a nod in the right direction was all we needed. So we rushed ahead to the future.

Tom Zaniello is a professor of English and the former director of the Honors Program at NKU.

13

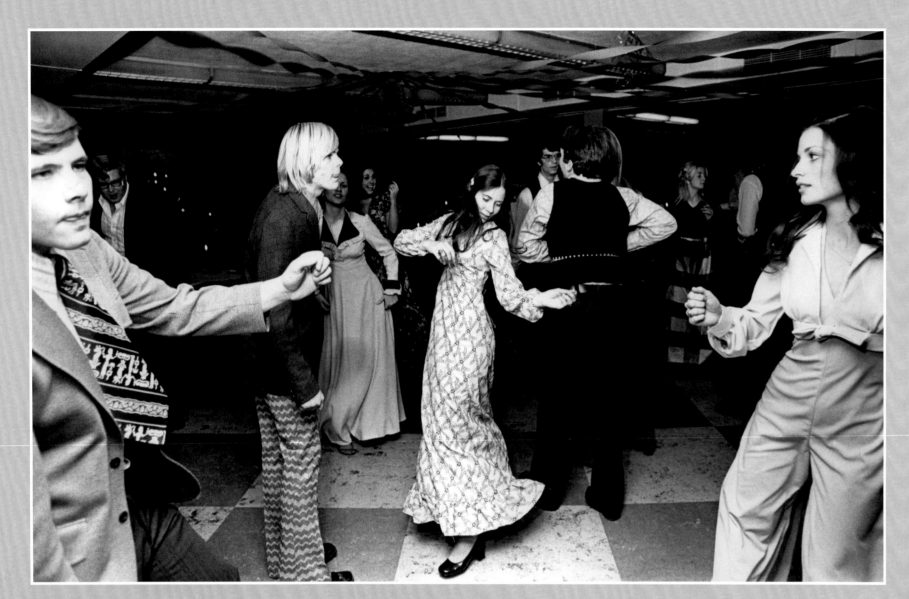

Above: Off-campus parade, early 1970s

Left: Homecoming dance, December 1974

Opposite page:

Top left: NKU drill team, the Golden Girls, participating in Cincinnati's St. Patrick's Day parade, March 1974

Bottom left: Choral concert in Regents Hall, 1970s

Far right: Registration, Regents Hall, early 1970s

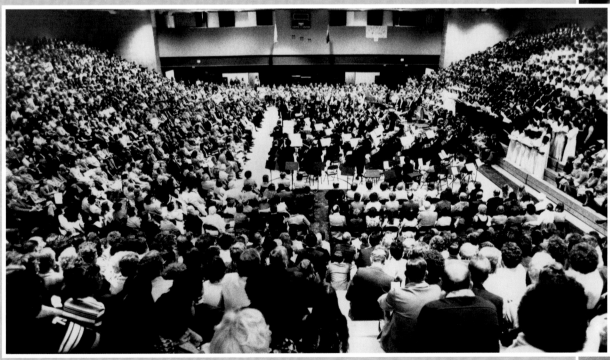

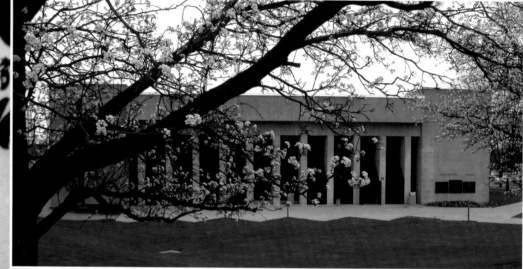

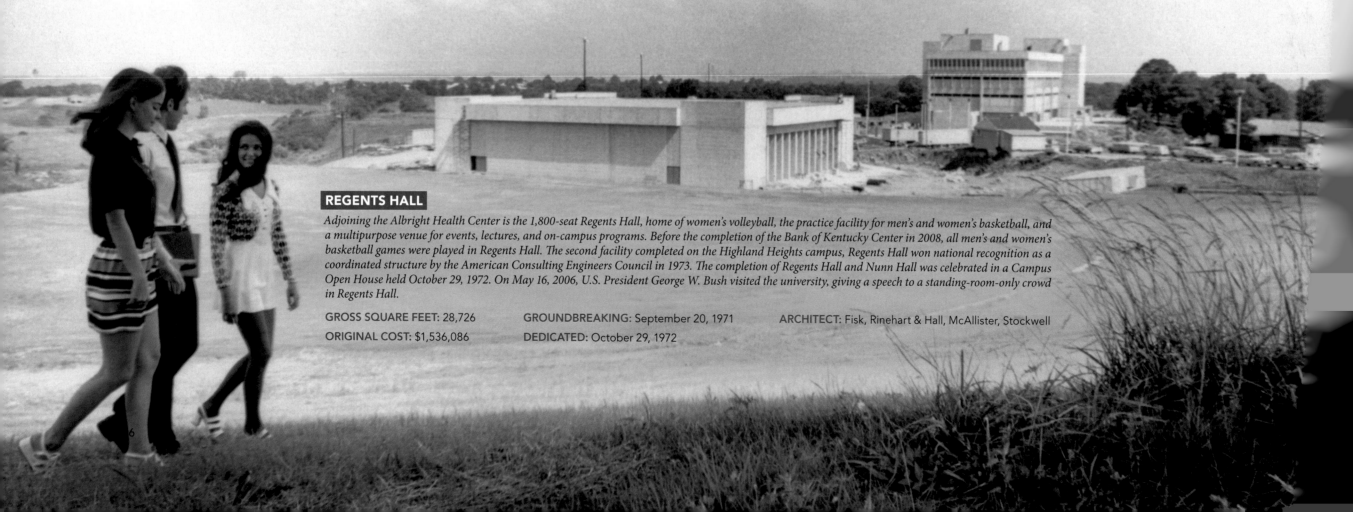

REGENTS HALL

Adjoining the Albright Health Center is the 1,800-seat Regents Hall, home of women's volleyball, the practice facility for men's and women's basketball, and a multipurpose venue for events, lectures, and on-campus programs. Before the completion of the Bank of Kentucky Center in 2008, all men's and women's basketball games were played in Regents Hall. The second facility completed on the Highland Heights campus, Regents Hall won national recognition as a coordinated structure by the American Consulting Engineers Council in 1973. The completion of Regents Hall and Nunn Hall was celebrated in a Campus Open House held October 29, 1972. On May 16, 2006, U.S. President George W. Bush visited the university, giving a speech to a standing-room-only crowd in Regents Hall.

GROSS SQUARE FEET: 28,726 GROUNDBREAKING: September 20, 1971 ARCHITECT: Fisk, Rinehart & Hall, McAllister, Stockwell

ORIGINAL COST: $1,536,086 DEDICATED: October 29, 1972

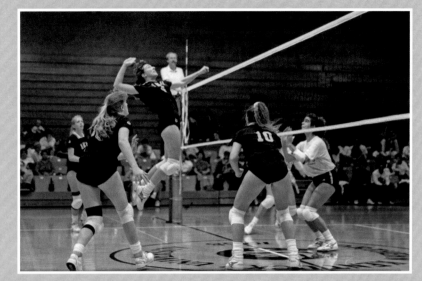

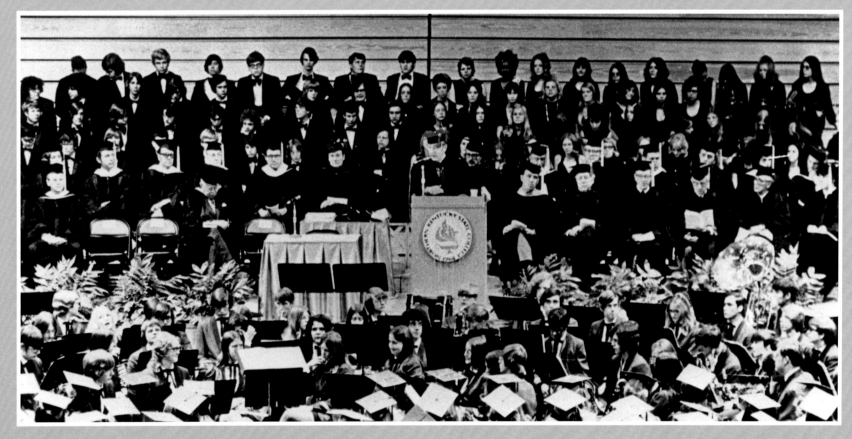

Above: Norse mascot, Hey You!, 1992

Top center: Tau Kappa Epsilon and Delta Zeta spectators in Regents Hall, 1970s

Top right: Women's volleyball match in Regents Hall, 1991

Bottom: First graduation ceremony in Regents Hall, 1973

Previous page:

Left: Regents Hall architectural rendering, circa 1970

Right: Regents Hall, June, 2001

Background image: Students walking past Regents Hall construction, circa 1973

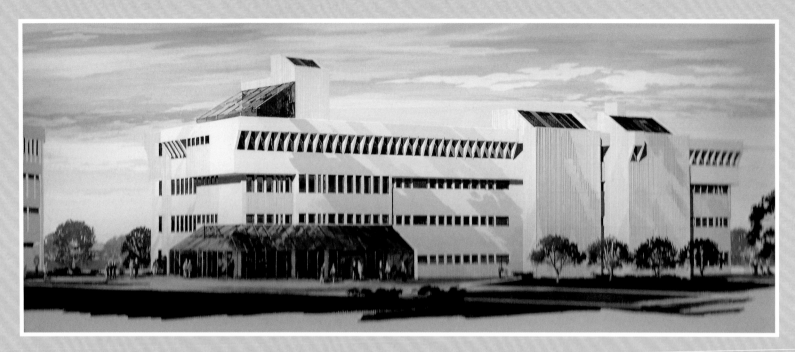

FOUNDERS HALL

Founders Hall, a five-story academic facility located on the west side of the Central Plaza, was the third building (the second academic building) completed on the Highland Heights campus and was known initially as the Natural Science Center. Currently, Founders Hall houses about 25 percent of the university's classrooms.

GROSS SQUARE FEET: 123,464

ORIGINAL COST: $6,424,865

GROUNDBREAKING: July 17, 1972

DEDICATED: September 29, 1974

RENOVATED: 1981

ARCHITECT: Fisk, Rinehart & Hall, McAllister, Stockwell

RENOVATION ARCHITECT: Fisk, Rinehart, Keltch & Meyer

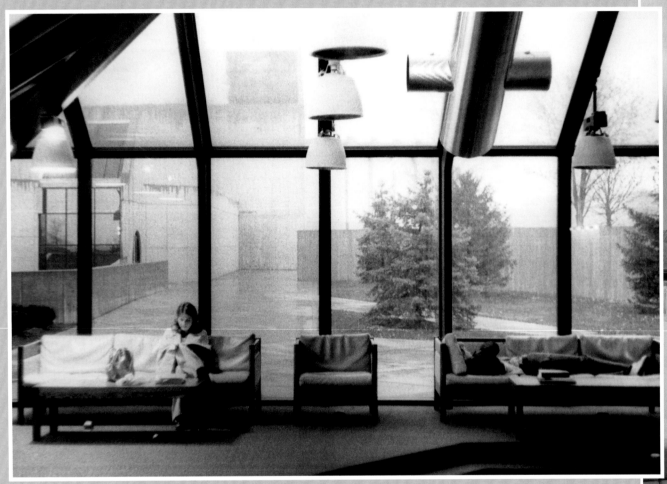

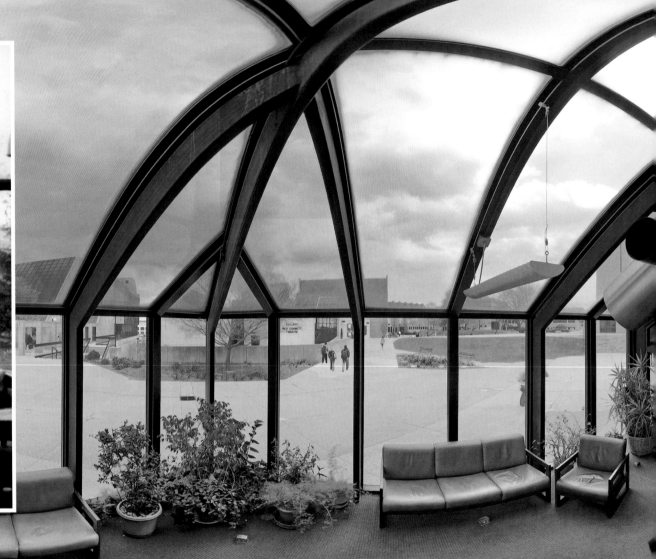

Above: Founders Hall lobby, late 1970s

Right: Founders Hall lobby, 2011

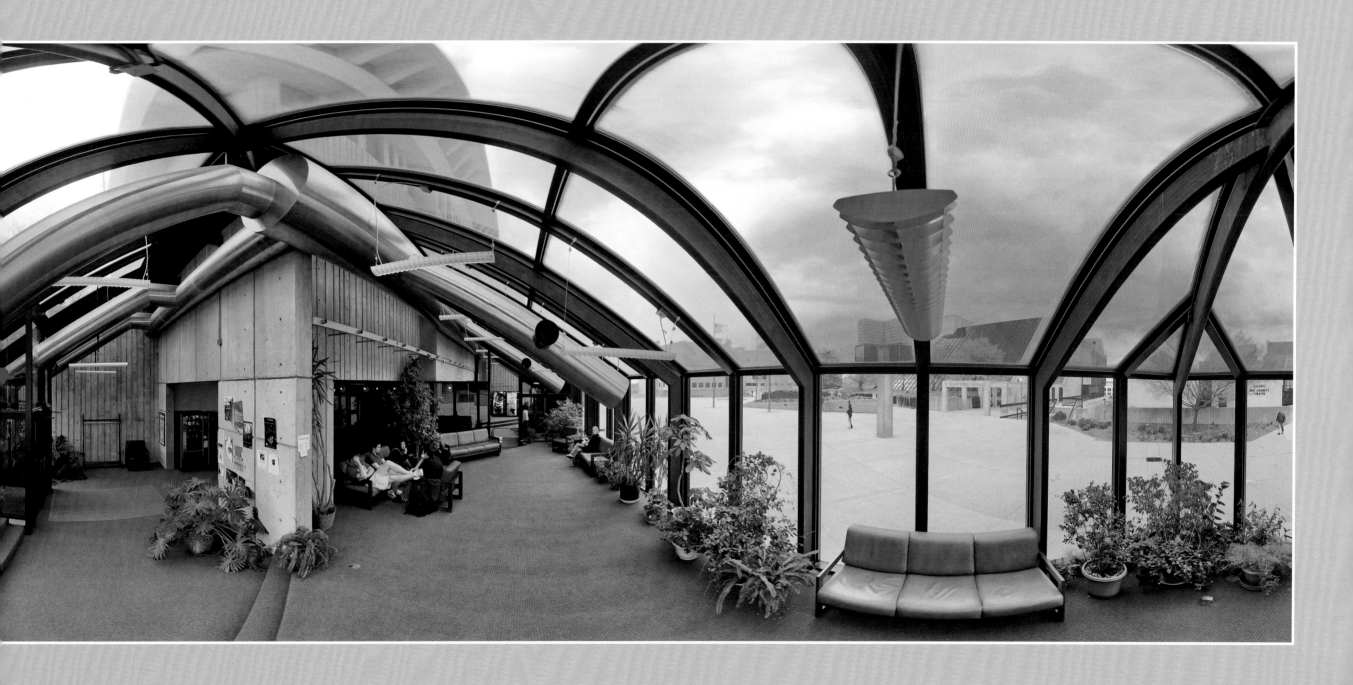

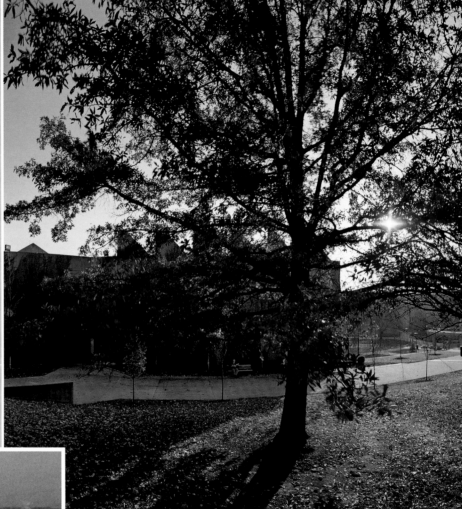

Above: Donald Judd's sculpture *Box* in front of Nunn Hall, 2010

Top left: Nunn Hall architectural rendering, circa 1970

Bottom left: Two views of the Nunn Hall construction site, 1971

22

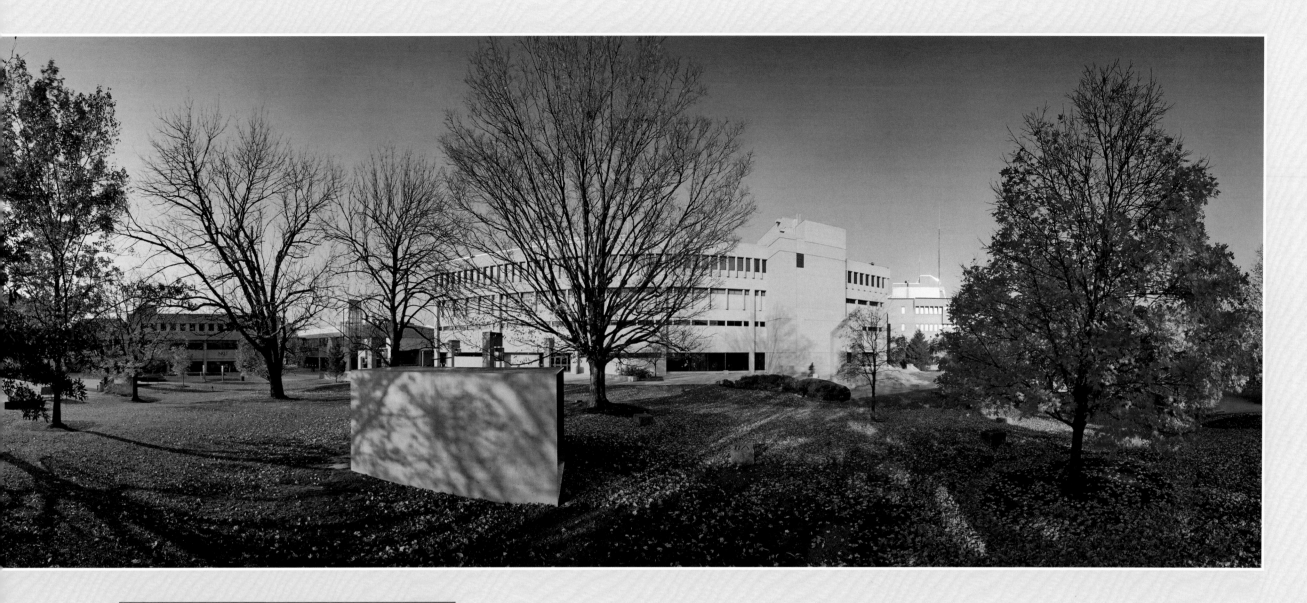

NUNN HALL–SALMON P. CHASE COLLEGE OF LAW

Nunn Hall was the first facility constructed on the new Highland Heights campus in 1972. Originally it housed nearly all academic and administrative functions, including classrooms and laboratories. Nunn Hall was renovated in 1981 at a cost of $1.5 million for the Salmon P. Chase College of Law, which still occupies the facility, including the law library, law classrooms, and faculty offices.

GROSS SQUARE FEET: 113,451

ORIGINAL COST: $5,085,194

GROUNDBREAKING: March 31, 1971

DEDICATED: October 29, 1972

RENOVATED: 1981

ARCHITECT: Fisk, Rinehart & Hall, McAllister, Stockwell

RENOVATION ARCHITECT: Gartner, Burdick, Bauer-Nilsen

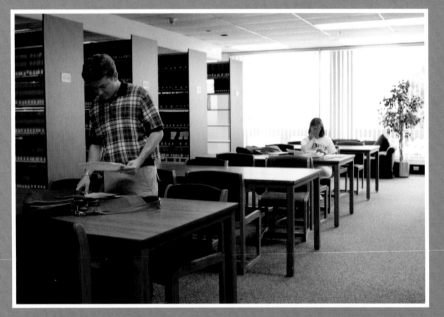

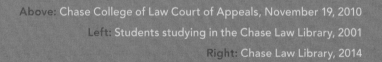

Above: Chase College of Law Court of Appeals, November 19, 2010

Left: Students studying in the Chase Law Library, 2001

Right: Chase Law Library, 2014

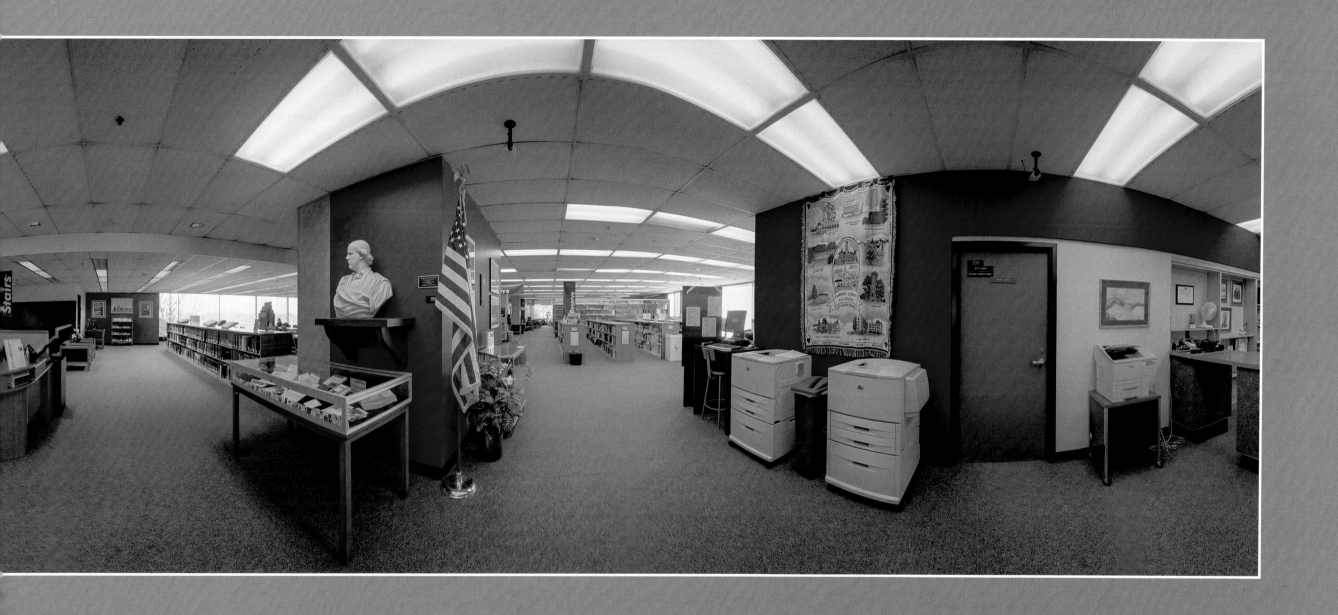

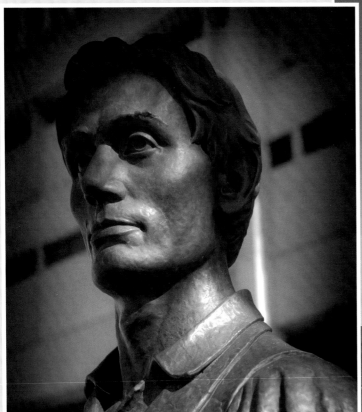

Above: A sculpture entitled *Abraham Lincoln* watches over the students entering the college of law. The bronze sculpture was created by Matt Langford and dedicated in November 2006. It features a young Lincoln holding an ax in one hand and a book in the other. Lincoln and Salmon P. Chase shared a long history that included Lincoln's appointing Chase the secretary of the Treasury of the United States in 1861 and chief justice of the U.S. Supreme Court in 1864. The sculpture was a gift made possible through the generosity of Oakley and Eva G. Farris.

Right: Matt Langford's *Abraham Lincoln* (2006) in front of Nunn Hall, 2010

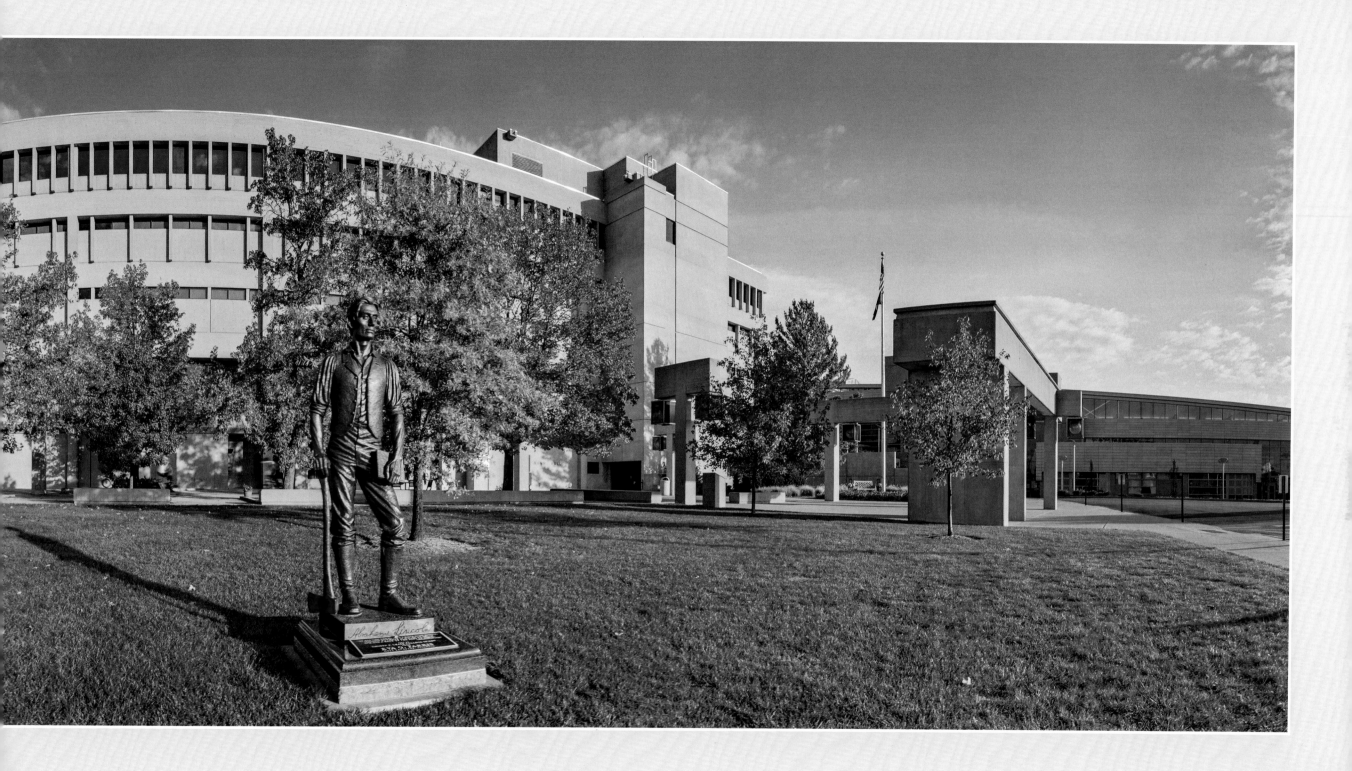

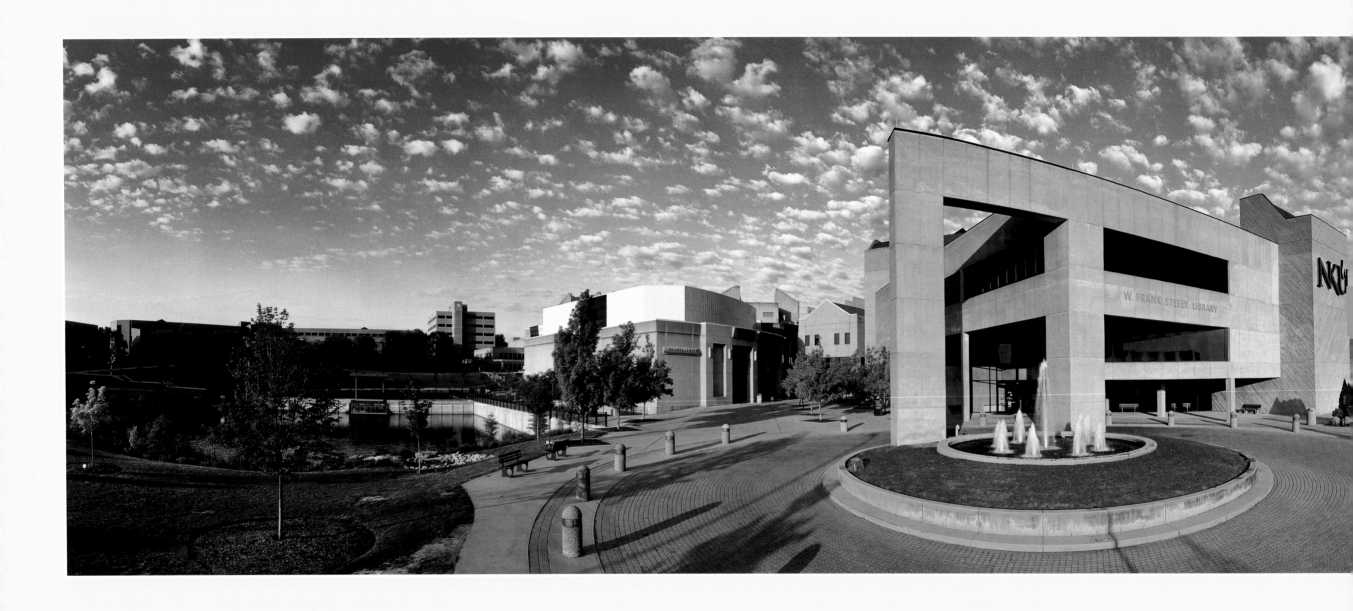

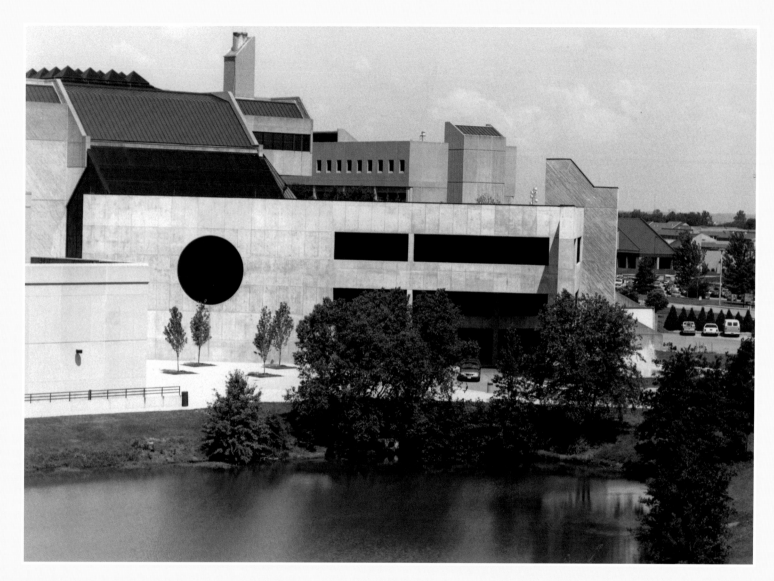

W. Frank Steely Library, 2010 (*left*) and 1995 (*right*)

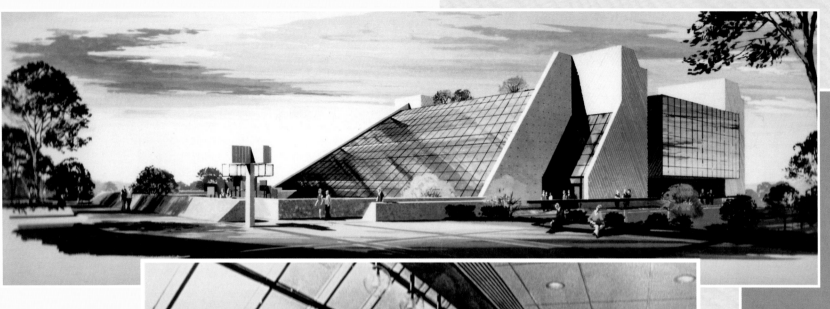

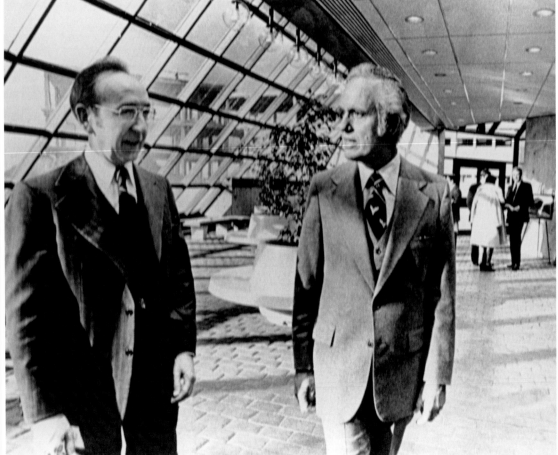

Above: W. Frank Steely Library loggia, 2010

Top left: W. Frank Steely Library architectural rendering, circa 1972

Bottom left: Frank Steely (*left*) and Governor Julian Carroll meet in the library loggia after the library dedication ceremony, November 23, 1975

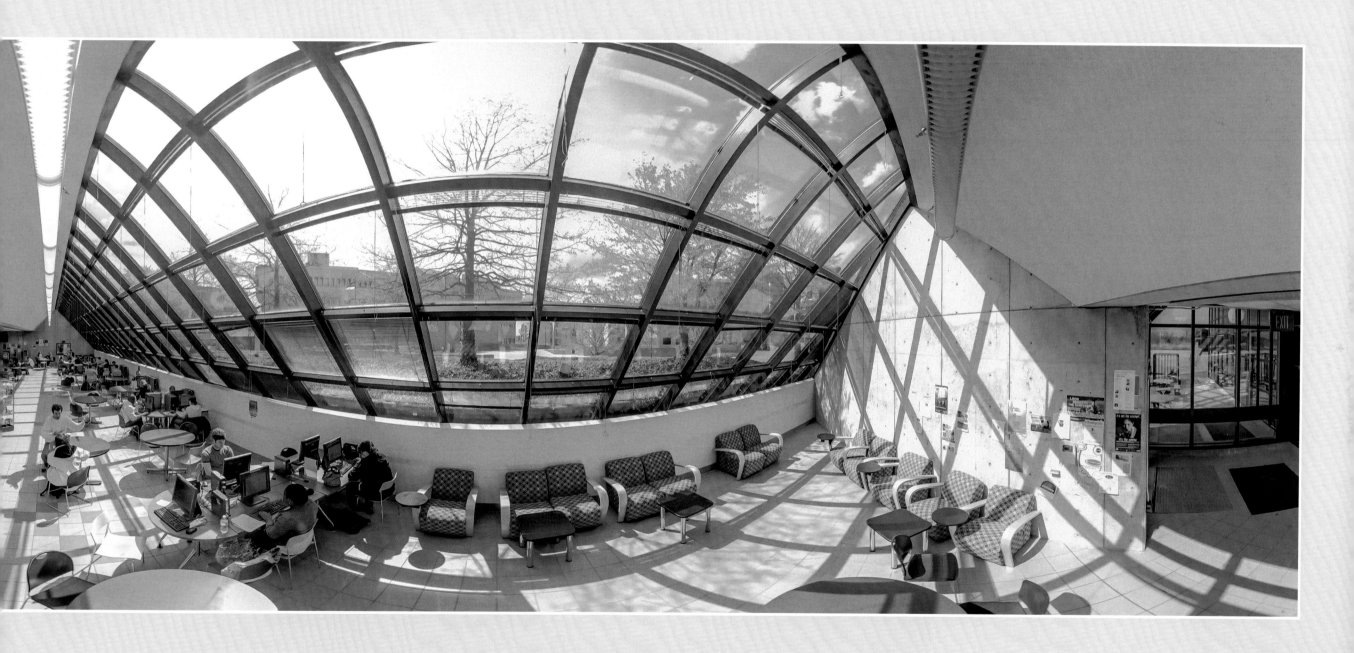

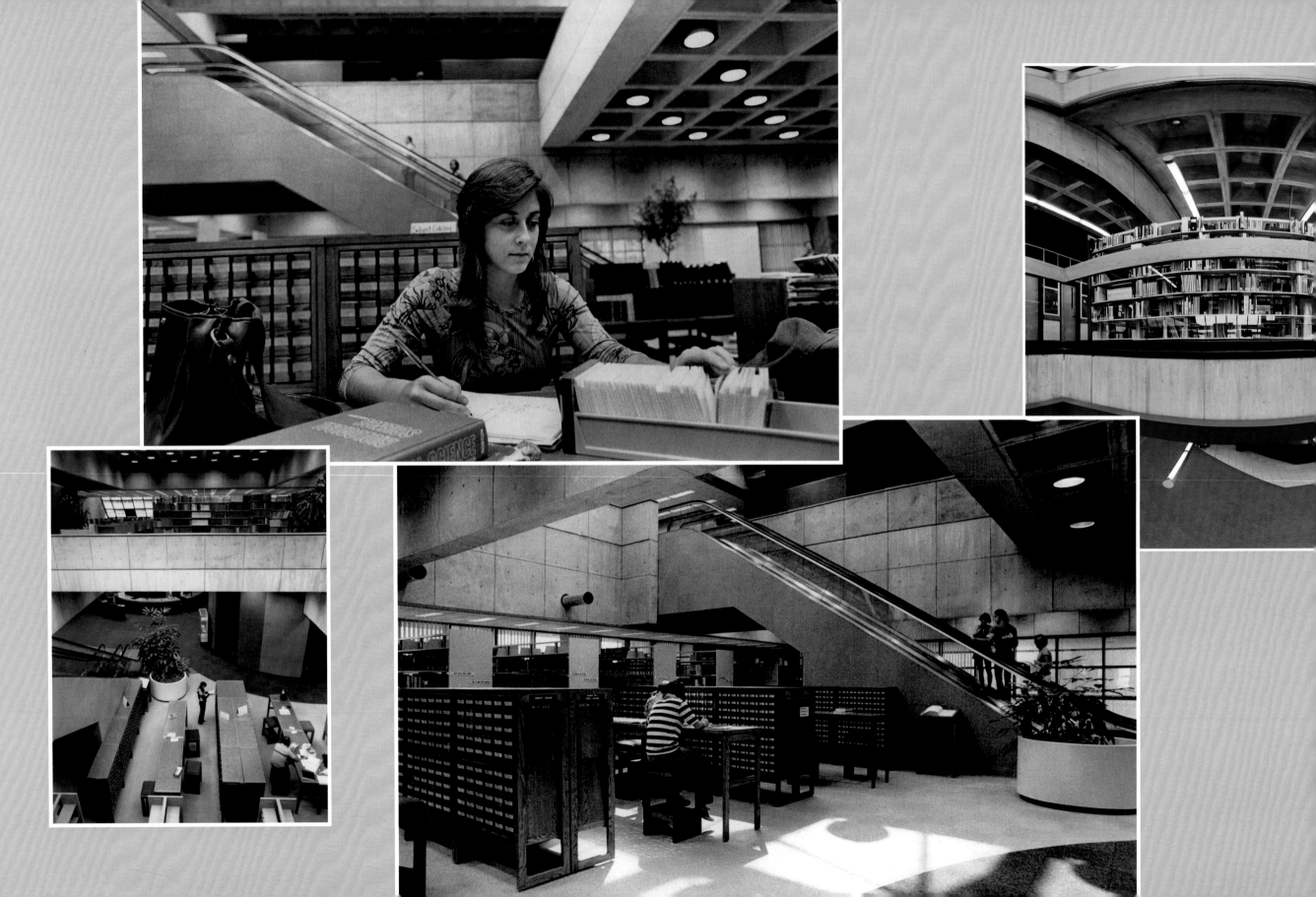

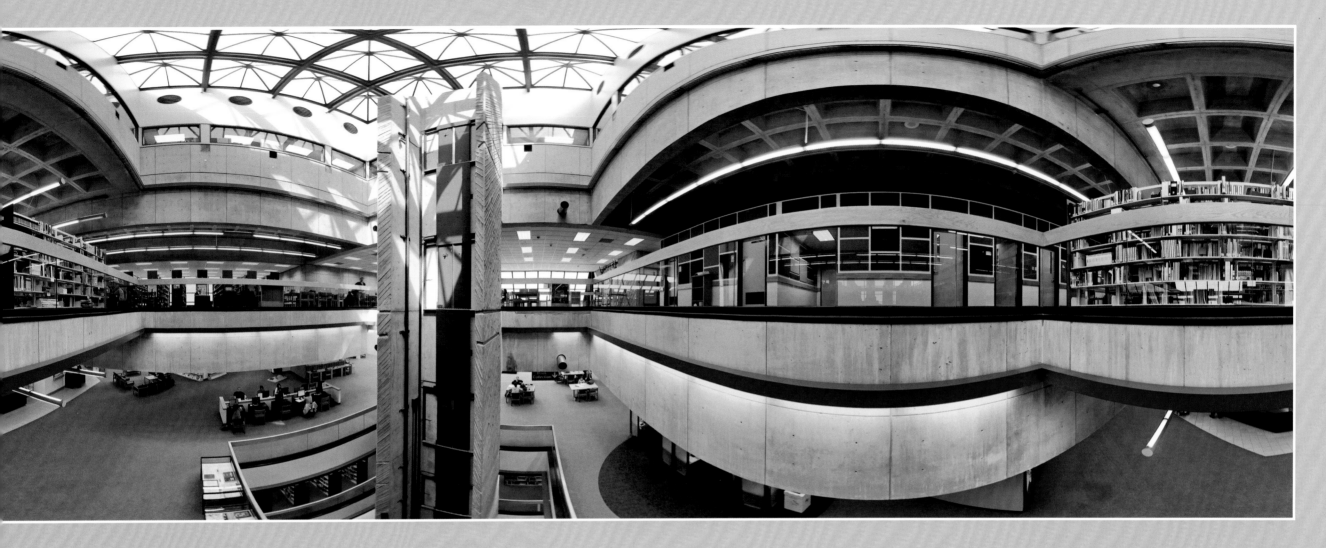

Above: W. Frank Steely Library, 2010

Previous page: Scenes from the W. Frank Steely Library, 1970s

W. FRANK STEELY LIBRARY

Called "the center jewel of the campus," Steely Library has received considerable publicity owing to its unique architecture and interior design. The library's attractive loggia, located at the plaza level under the striking forty-five-degree sloping glass wall, and its coffee shop are a popular campus destination.

GROSS SQUARE FEET: 141,665 **GROUNDBREAKING:** October 22, 1973 **ARCHITECT:** Fisk, Rinehart & Hall, McAllister, Stockwell

ORIGINAL COST: $5,305,183 **DEDICATED:** November 23, 1975

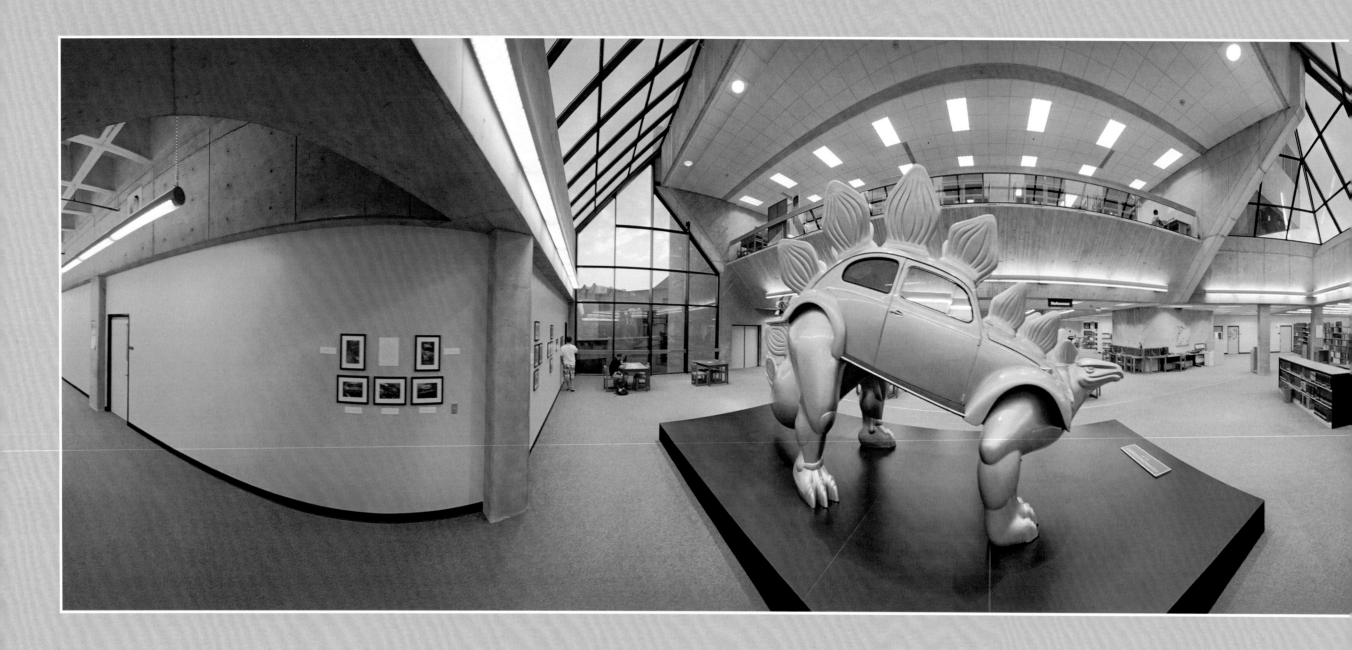

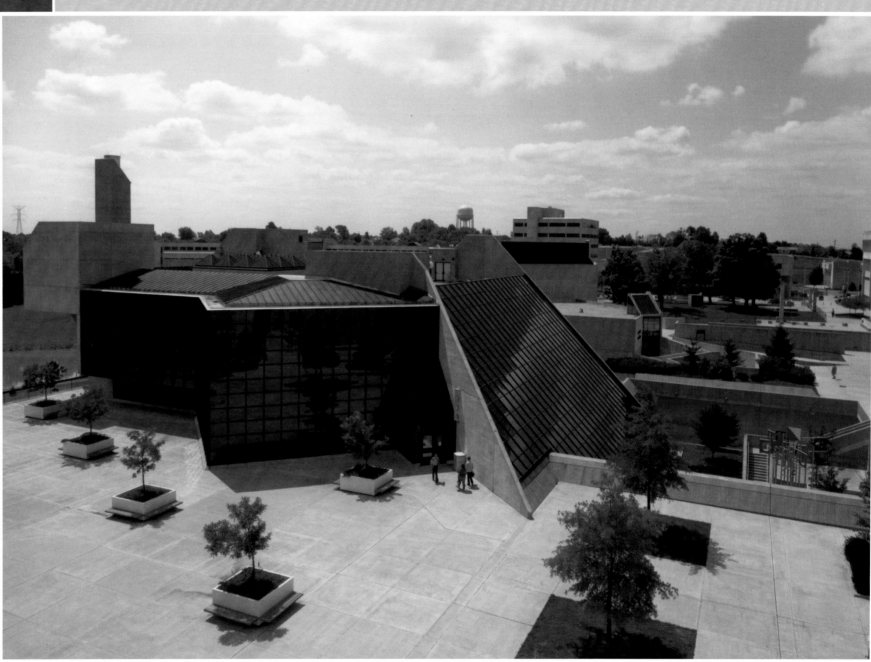

Above: Patricia A. Renick's *Stegowagenvolkssaurus* (1974) in the W. Frank Steely Library, 2010

Right: W. Frank Steely Library's original exterior, 1980s

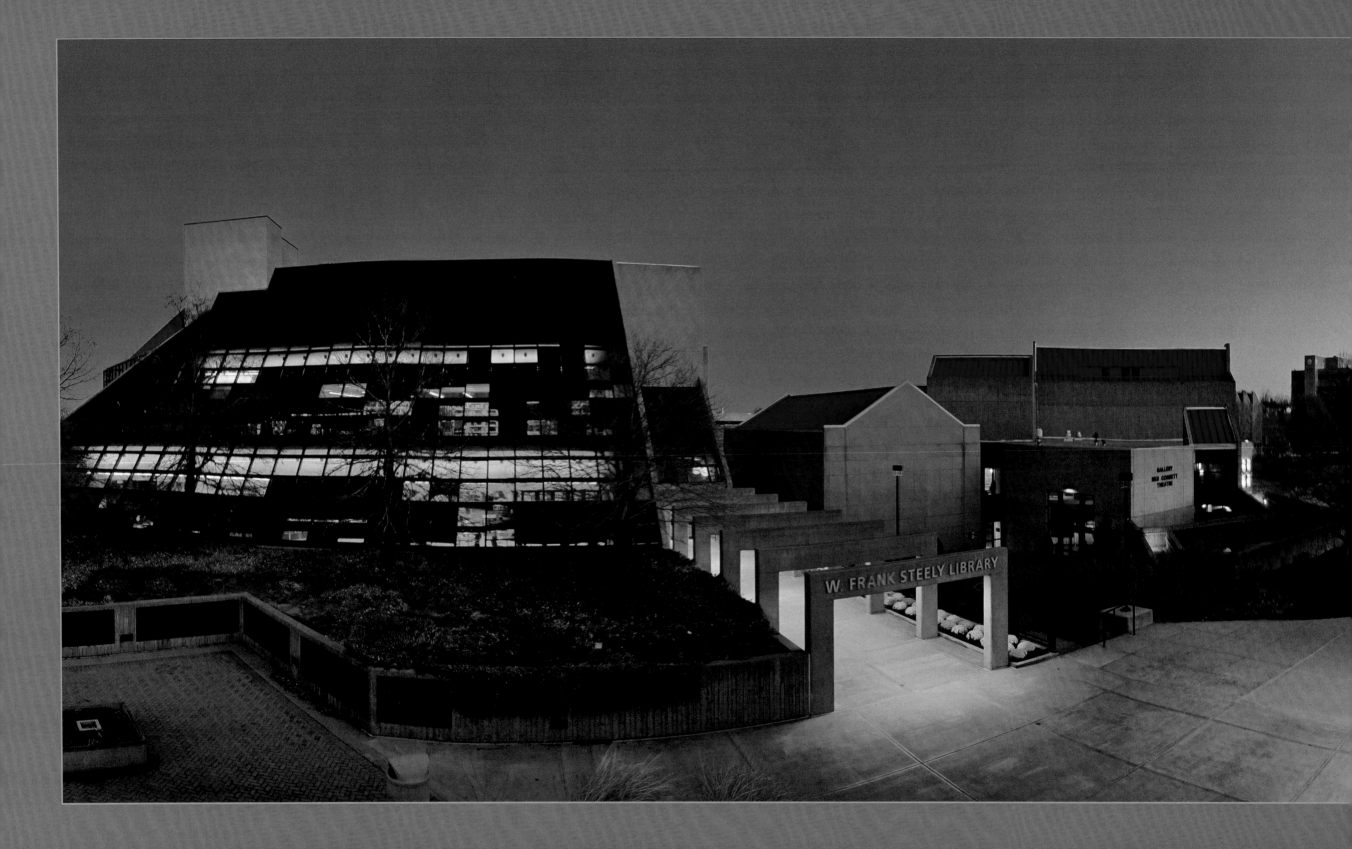

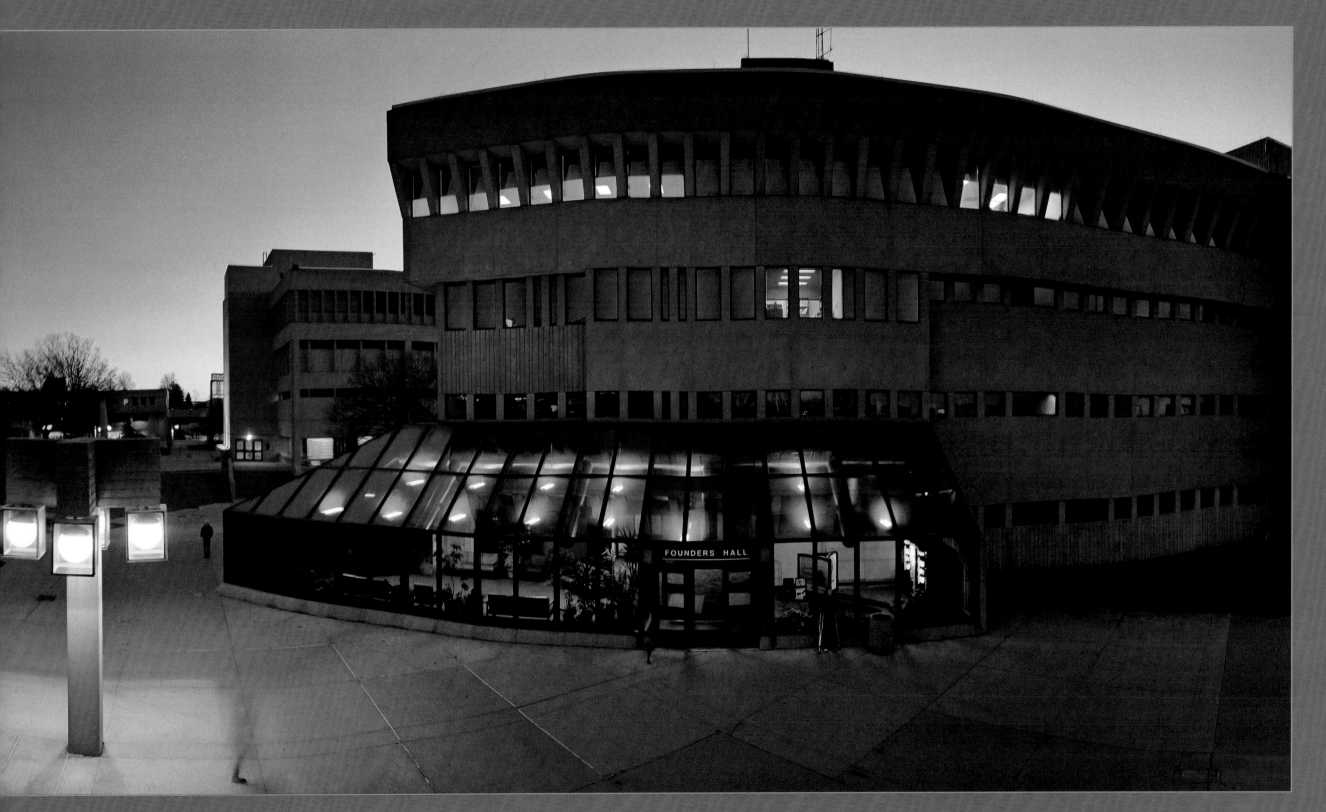

FOUNDERS HALL

W. Frank Steely Library and Founders Hall, 2011

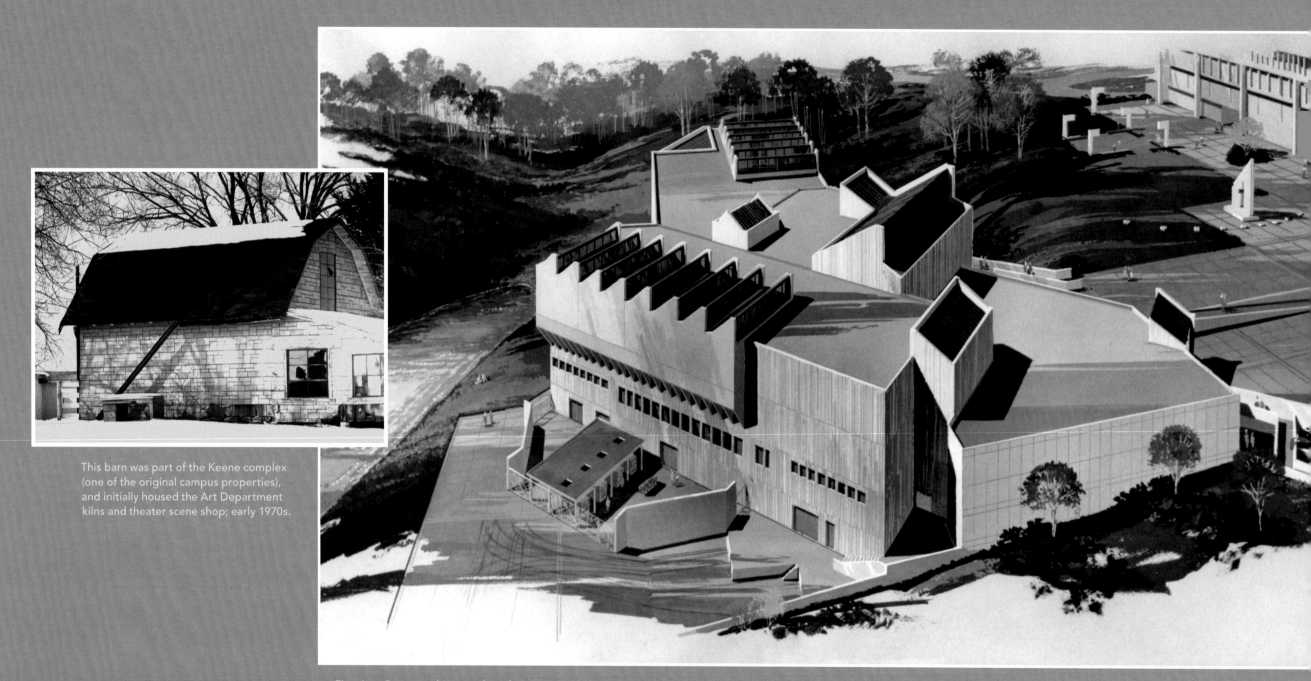

This barn was part of the Keene complex (one of the original campus properties), and initially housed the Art Department kilns and theater scene shop; early 1970s.

Fine Arts Center architectural rendering, circa 1974

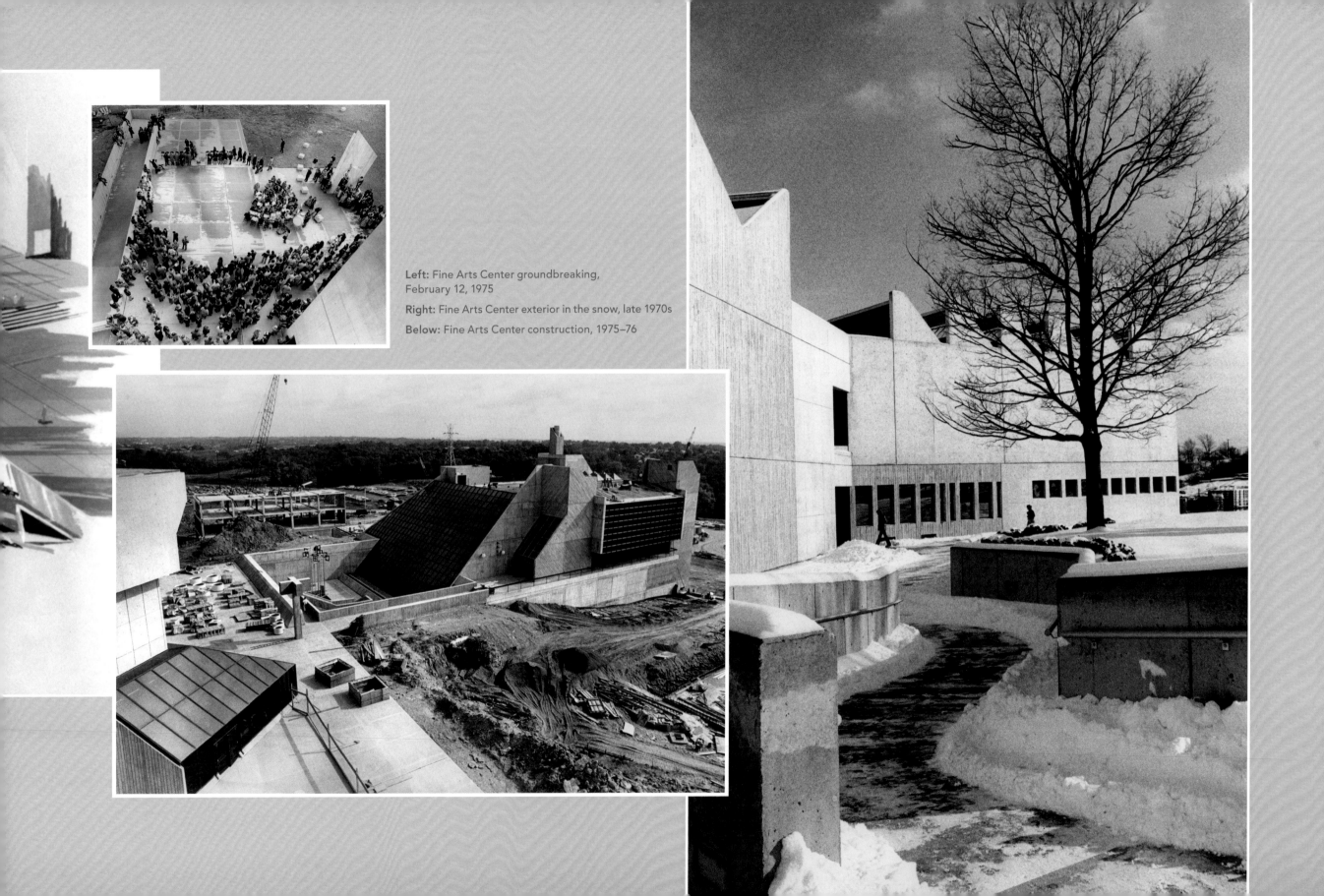

Left: Fine Arts Center groundbreaking, February 12, 1975

Right: Fine Arts Center exterior in the snow, late 1970s

Below: Fine Arts Center construction, 1975–76

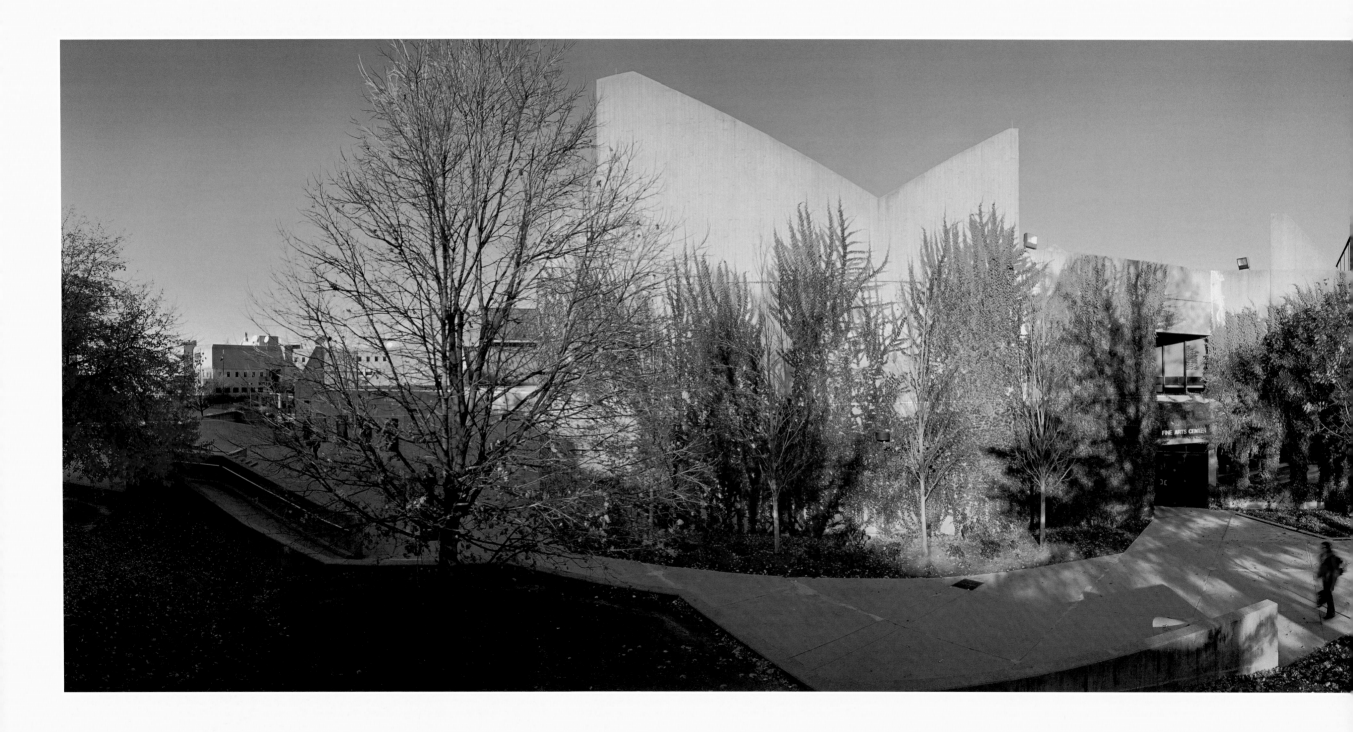

Left: Fine Arts Center, 2010

Below: Fine Arts Department faculty and staff, circa 1980: Barry Andersen, photography; Gary Armstrong, graphic design and drawing; Kevin Booher, printmaking; Neal Jowaisas, ceramics (deceased); Vern Shelton, Art Department chair; Howard Storm, painting; Terri Jowaisas, slide librarian; and Mike Skop, sculpture (deceased)

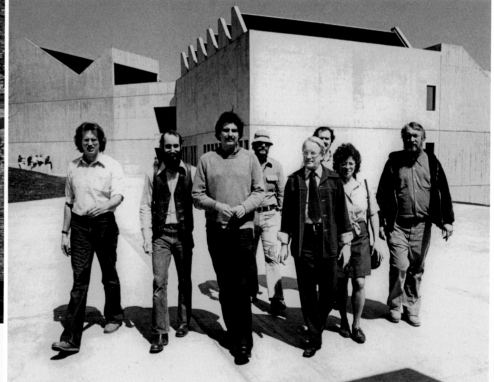

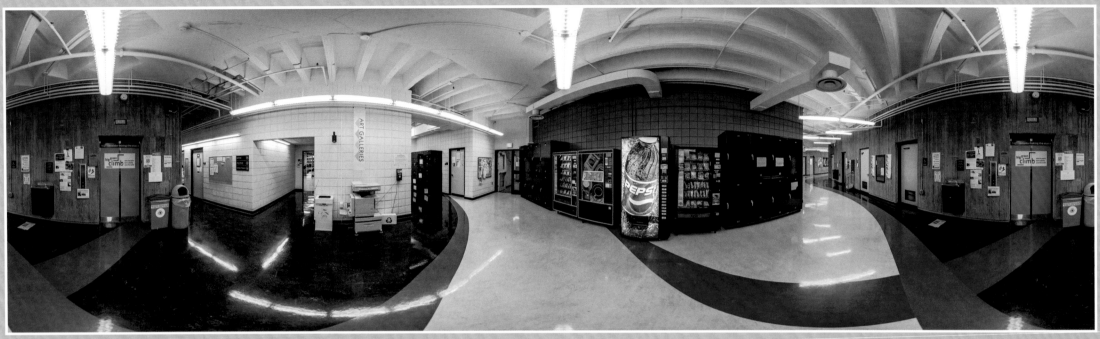

FINE ARTS CENTER

The original building accommodates skylit art studios, the Rosemary Stauss Theatre and NKU Corbett Theatre, two art galleries, dance studios, classrooms, and faculty offices and studios. The expansion, constructed immediately adjacent to the east and north facades of the original building, accommodates the 637-seat Greaves Concert Hall, band room, choir room, faculty studios, practice rooms, and other instructional spaces.

GROSS SQUARE FEET: 159,584

ORIGINAL COST: $6,134,590

GROUNDBREAKING: February 12, 1975

DEDICATED: October 16, 1977

RENOVATED: 1992

ARCHITECT: Fisk, Rinehart & Hall, McAllister, Stockwell

RENOVATION ARCHITECT: KZF Incorporated

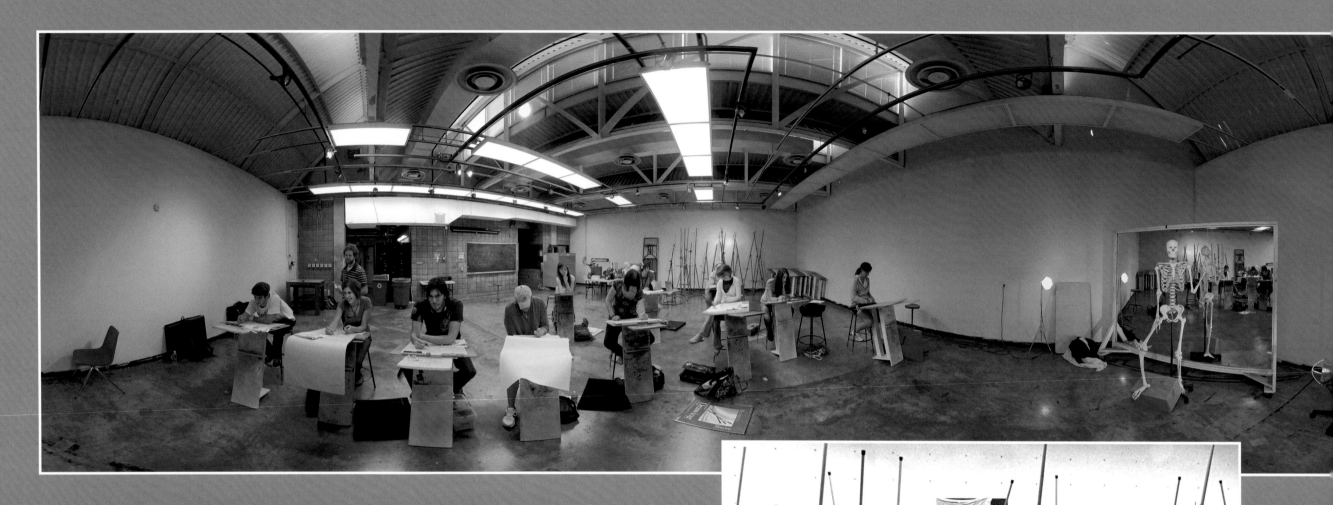

Above: Fine Arts Center drawing studio, 2010

Right: Fine Arts Center drawing studio, late 1970s

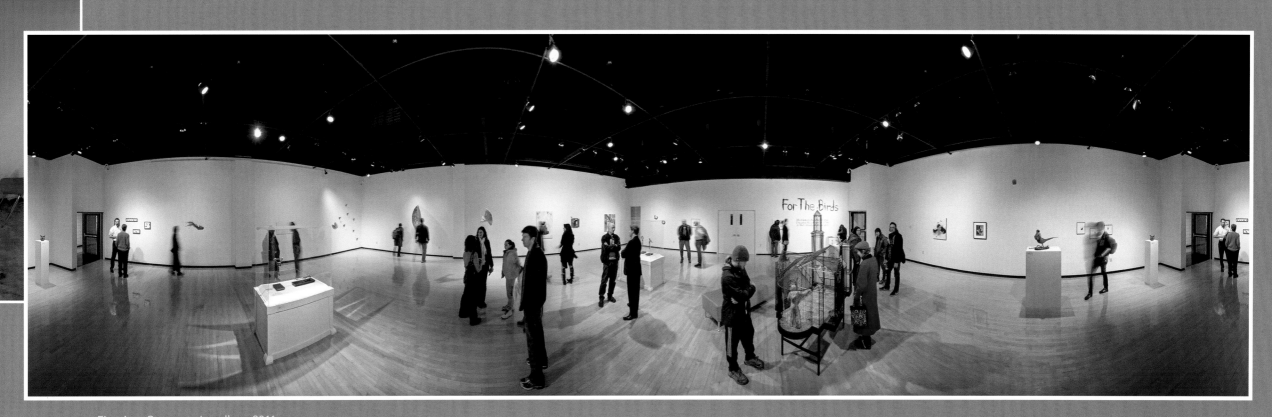

Fine Arts Center main gallery, 2011

45

Fine Arts Center, 2010

A. D. ALBRIGHT, 1976–1983

by Robert K. Wallace

AFTER THE VOLATILITY OF THE STEELY PRESIDENCY AND THE TENSE TRANSITIONAL YEAR UNDER INTERIM PRESIDENT RALPH TESSENEER, A. D. ALBRIGHT PRESIDED OVER A PERIOD OF RELATIVE CALM AND PROFESSIONAL CONSOLIDATION AS THE HIGHLAND HEIGHTS CAMPUS CONTINUED TO EXPAND DRAMATICALLY. IN JUNE 1976, A MONTH BEFORE PRESIDENT ALBRIGHT TOOK OFFICE, THE SCHOOL'S NAME OFFICIALLY CHANGED FROM NORTHERN KENTUCKY STATE COLLEGE TO NORTHERN KENTUCKY UNIVERSITY.

A native of Washington, D.C., who earned his advanced degrees in education from the University of Tennessee and New York University, Albright had a distinguished teaching and administrative career at the University of Kentucky before becoming director of the state's Council of Higher Education, experience that prepared him well for both the academic and political challenges he would face as president of the newly named NKU.

The most visible evidence of the Albright legacy is the numerous buildings that were planned and completed between his arrival in 1976 and his retirement in 1983. These new buildings enabled the academic departments that were crammed into Nunn Hall to spread out into their own buildings—and they gave our commuter students things to do on campus beyond finding a parking place and attending class. These improvements had begun under the Steely administration, with the completion of the science building

(now Founders Hall) in 1974 and Steely Library in 1975. Under Albright, the following new buildings were added to the Highland Heights campus (in chronological order):

• Landrum Academic Center, November 1976 (which originally housed the nursing program in addition to departments in the humanities and social sciences)

• Fine Arts Center, fall 1977 (which included both a black-box and a main-stage theater but no art gallery or concert hall)

• University Center, fall 1977 (which had originally been thirteenth on the list of projected buildings but was accelerated by faculty advocates)

• Business-Education-Psychology Center (now the Mathematics, Education & Psychology Center), October 1980 (at the time of its dedication, the largest classroom building in the state)

• Administrative Center, July 1982 (later named for Ken Lucas, who had been chair of the Board of Regents during our crucial formative years)

• The renovated Nunn Hall became Chase College of Law, spring 1981 (the law school that had moved from Cincinnati to the Covington campus in 1972 arrives at Highland Heights)

• Commonwealth Hall and Kentucky Hall, spring 1982 (our commuter campus gets its first residence halls, providing a campus home for four hundred students)

• Groundbreaking for the Albright Health Center, July 1982 (expansion of Regents Hall to house the nursing program and student recreation facilities, completed July 1984 during Leon Boothe's tenure as president)

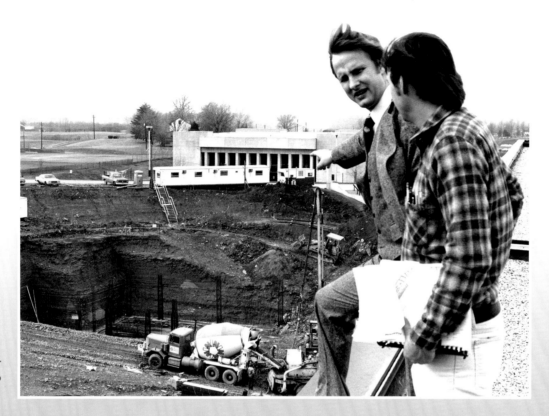

Lucas Administrative Center
construction, 1976

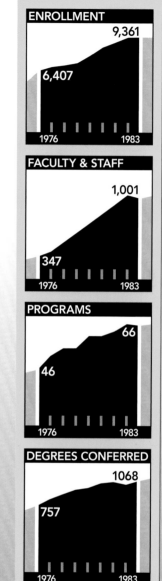

ENROLLMENT
9,361
6,407
1976 1983

FACULTY & STAFF
1,001
347
1976 1983

PROGRAMS
66
46
1976 1983

DEGREES CONFERRED
1068
757
1976 1983

This steady stream of new buildings allowed us to just barely keep up with the rising tide of new students, but finally more and more of our classes were housed in buildings designed for the subjects being taught. That made us feel a lot more like a university, and so did the fact that the Albright administration, under the leadership of Provost Janet Travis (1977–79), instituted professional standards for granting tenure and promotion, processes that had been somewhat haphazard and irregular during the Steely and Tesseneer years. The implementation of the new procedures created growing pains of a different kind, but it provided a secure foundation for our future as an institution of higher learning. In the middle of this process, in December 1978, NKU was awarded full accreditation by the Southern Association of Colleges and Schools.

As the internal procedures for academic affairs were being professionalized, the university was beginning to become a cultural center for the northern Kentucky community. In 1976, through a grant from the National Endowment for the Arts, the university commissioned sculptures from two prominent artists, Donald Judd and Red Grooms. Judd's minimalist, conceptual aluminum *Box* was installed between Nunn Hall and the Fine Arts Center, where it remains today. Grooms's colorful, playful *Way Down East* was installed on a low pedestal between the Fine Arts Center and the University Center. It was featured on a national tour by the Smithsonian Institution before being removed from the plaza after a spirited debate early in the Votruba administration over the cinematic and social legacy of D. W. Griffith, the filmmaker

whose *Way Down East* had inspired the sculpture.

Under the leadership of Provost Lyle Gray, who succeeded Janet Travis in 1980, the Albright administration began to bring an impressive array of scholars, authors, and speakers to campus, among them Jacques Barzun, John Ciardi, Jane Goodall, Alex Haley, and Ken Kesey. Secretary of State Dean Rusk and the journalist Eric Severeid were among the early commencement speakers in Regents Hall, which also hosted concerts by such musicians as Judy Collins, Dolly Parton, Sly and the Family Stone, Linda Ronstadt, and Lynyrd Skynyrd. Under the leadership of Jack Wann, the Theater Department inaugurated its summer dinner theater in 1977 and its YES Festival of New Plays in 1983, the latter giving NKU theater majors the opportunity to perform in three world premieres every other April.

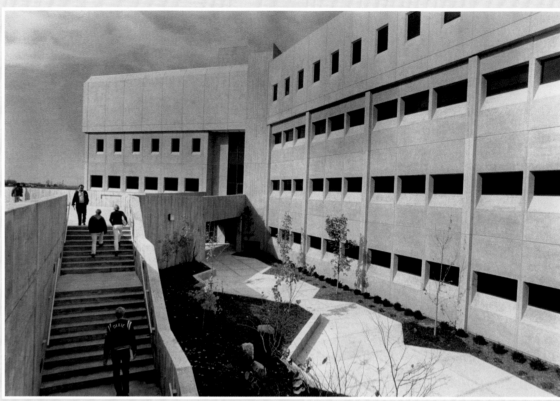

During the Albright administration, severe budget cuts from Frankfort threatened the fledgling athletics program, which had gotten under way during the Steely administration, so severely that for a time our varsity athletics were limited to men's and women's basketball and women's volleyball. By the time Albright retired, however, the program was back on track, for Albright hired Jane Meier as athletic director and Nancy Winstel as women's basketball coach, inaugurating a golden age in NKU athletics that extended until we made the transition to Division I in 2012.

In addition to adding a variety of undergraduate majors and selected graduate programs to our academic offerings, the Albright administration encouraged other innovations to capitalize on our status as a relatively young university lacking hidebound traditions. Our women's studies pro-

gram was established in 1978, as was our reentry center for nontraditional students, and a dean of experimental studies was appointed in the same year. The Honors Program was founded in 1981, and in the summer of 1983 NKU offered its first courses as part of the Cooperative Center for Study in Britain, formally initiating opportunities for study abroad that have increased exponentially in subsequent years.

Though not as volatile as the Steely years, the Albright years were full of energetic organizational growth. We were still very young as a university, but we had matured considerably. By April 5, 1983, when the Board of Regents chose Leon Boothe to succeed A. D. Albright, many of the young faculty who had come to the new Highland Heights campus straight out of graduate school in 1972 were among the more seasoned old hands in their departments.

Left: Landrum Academic Center architectural rendering, circa 1974

Center: Two views of the Landrum Academic Center exterior, 1976

Far right: Students socializing in front of Steely Library, with Landrum in the background, late 1970s

Robert K. Wallace is the regents professor of literature at NKU and the author of a variety of books on literature and the arts. He also wrote Thirteen Women Strong: The Making of a Team, *which tells the story of NKU's women's basketball squad, culminating in its second national championship in 2008.*

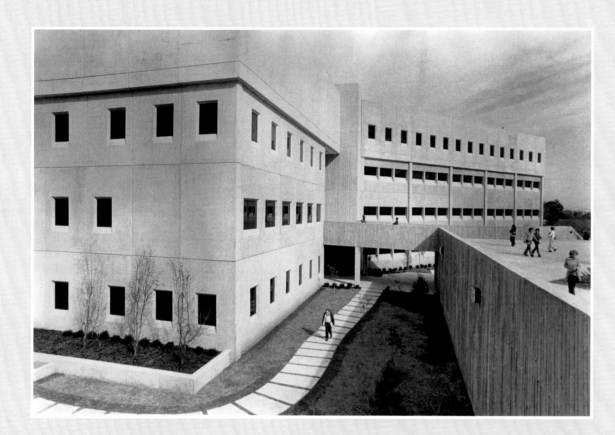

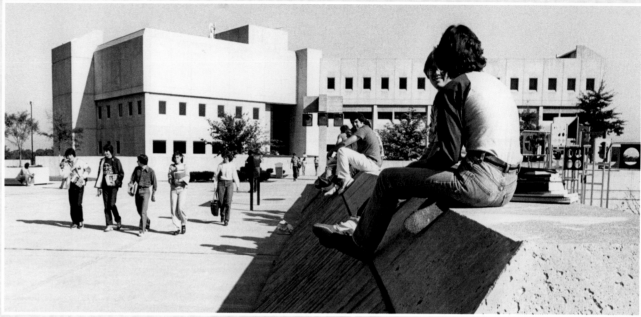

CHARLES O. LANDRUM ACADEMIC CENTER

Home to many undergraduate classrooms, Landrum is the busiest of NKU's classroom buildings. It has five floors and two large lecture halls, numerous classrooms, labs, and faculty offices.

GROSS SQUARE FEET: 100,500

ORIGINAL COST: $4,919,371

GROUNDBREAKING: May 1, 1975

DEDICATED: November 6, 1976

ARCHITECT: Edward J. Beiting Jr., P.S.C.

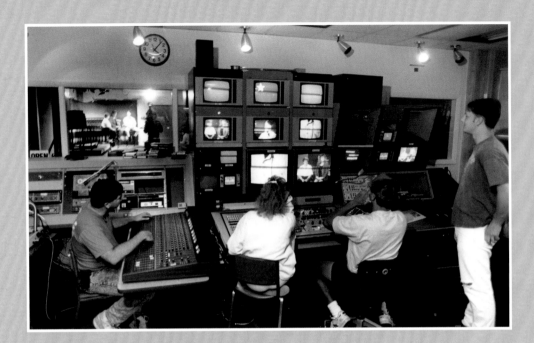

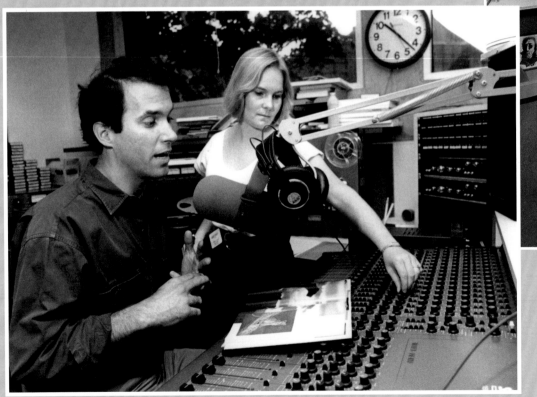

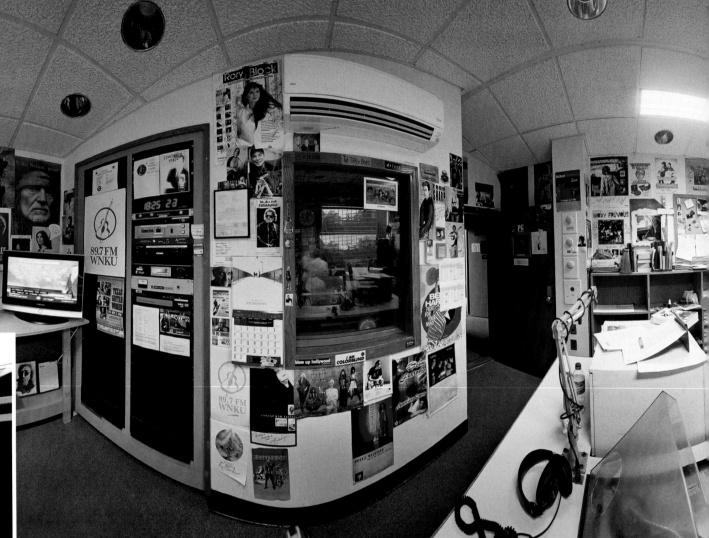

Above: Mr. Rhythm Man broadcasting in WNKU Studios in Landrum Academic Center, 2011

Top left: Television and Media Control Room in Landrum Academic Center, 1980s

Bottom left: WNKU Studios in Landrum Academic Center, late 1980s

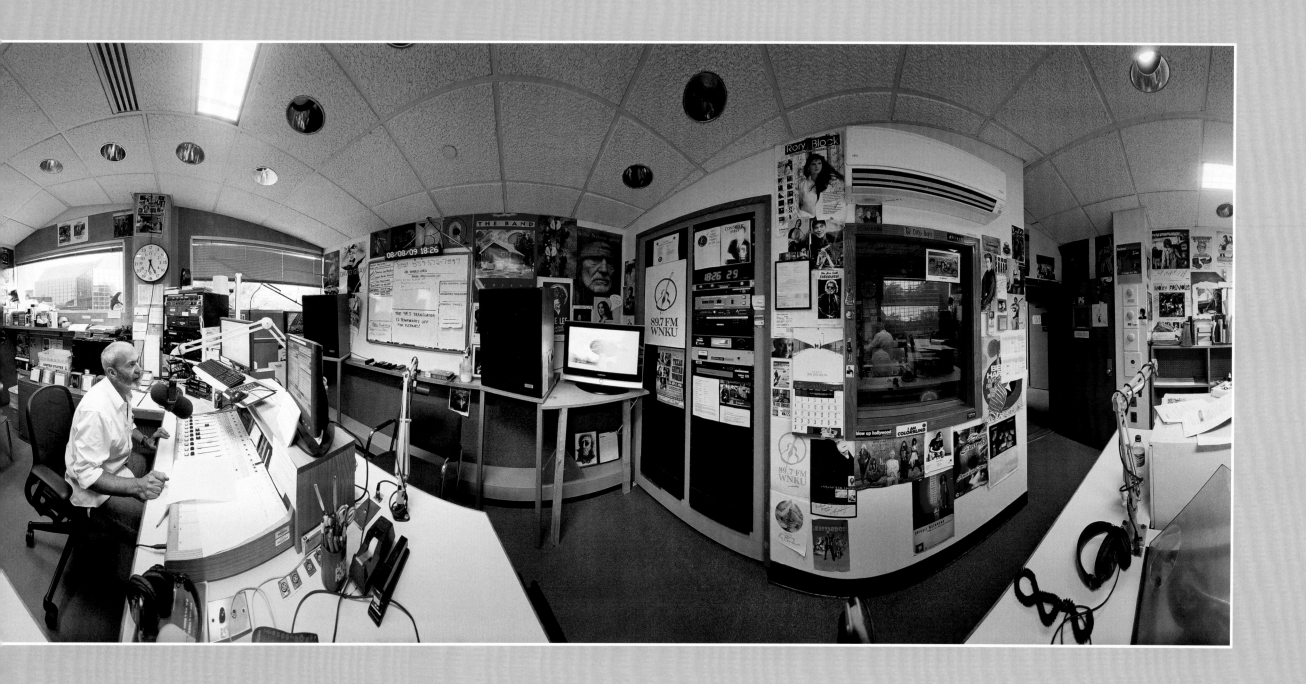

Above: Studio 89 live performance in Landrum Academic Center, 2009
Right: Studio 89 live performance in the new Griffin Hall Digitorium, 2012

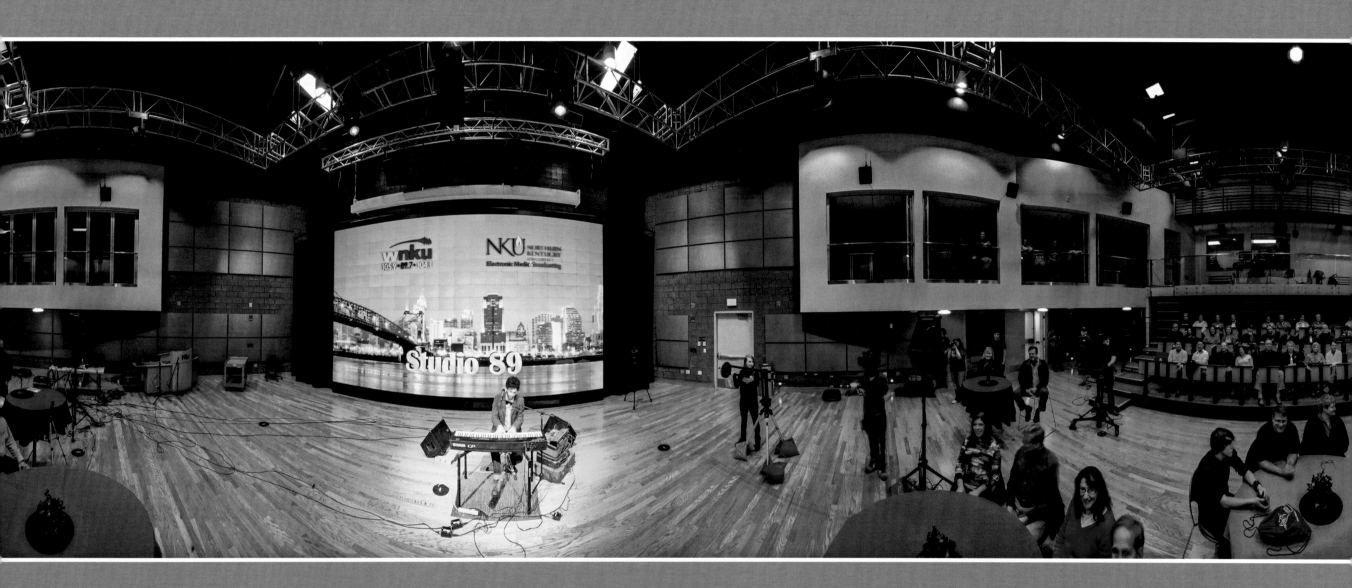

Above: Mathematics, Education & Psychology Center, spring 2001

Left: Mathematics, Education & Psychology Center (formerly Business-Education-Psychology, or BEP, Center) architectural rendering, circa 1977

Right: Mathematics, Education & Psychology Center, 2014

MATHEMATICS, EDUCATION & PSYCHOLOGY CENTER

The building houses classrooms for mathematics, education, and psychology, in addition to laboratories and two auditoriums. The Early Childhood Center is located on the first floor and opens onto an outdoor playground.

GROSS SQUARE FEET: 128,283

ORIGINAL COST: $7,239,523

GROUNDBREAKING: May 11, 1978

DEDICATED: October 24, 1980

ARCHITECT: Fisk, Rinehart, Keltch, Meyer

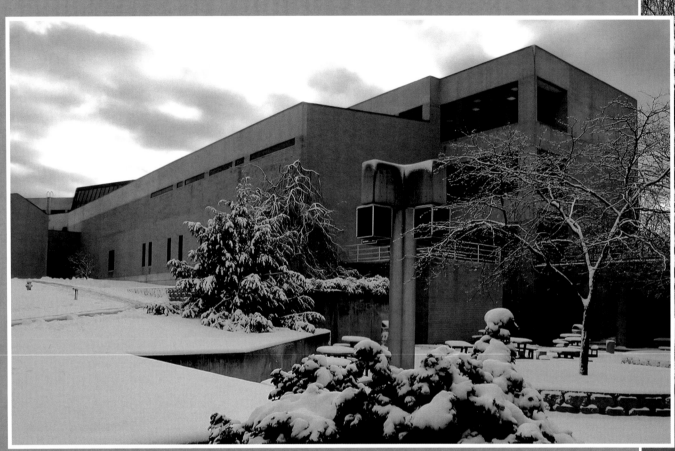

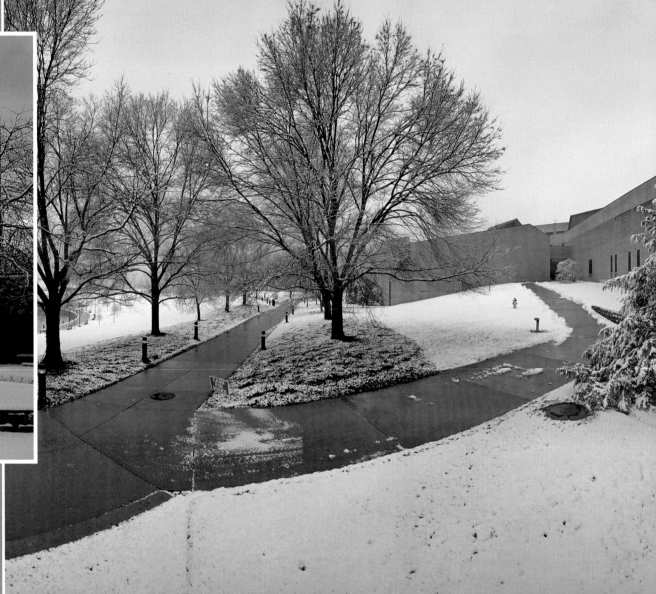

Above: Mathematics, Education & Psychology Center in the snow, January 8, 2002

Right: Mathematics, Education & Psychology Center, Lucas Administrative Center, and University Center in the snow, 2010

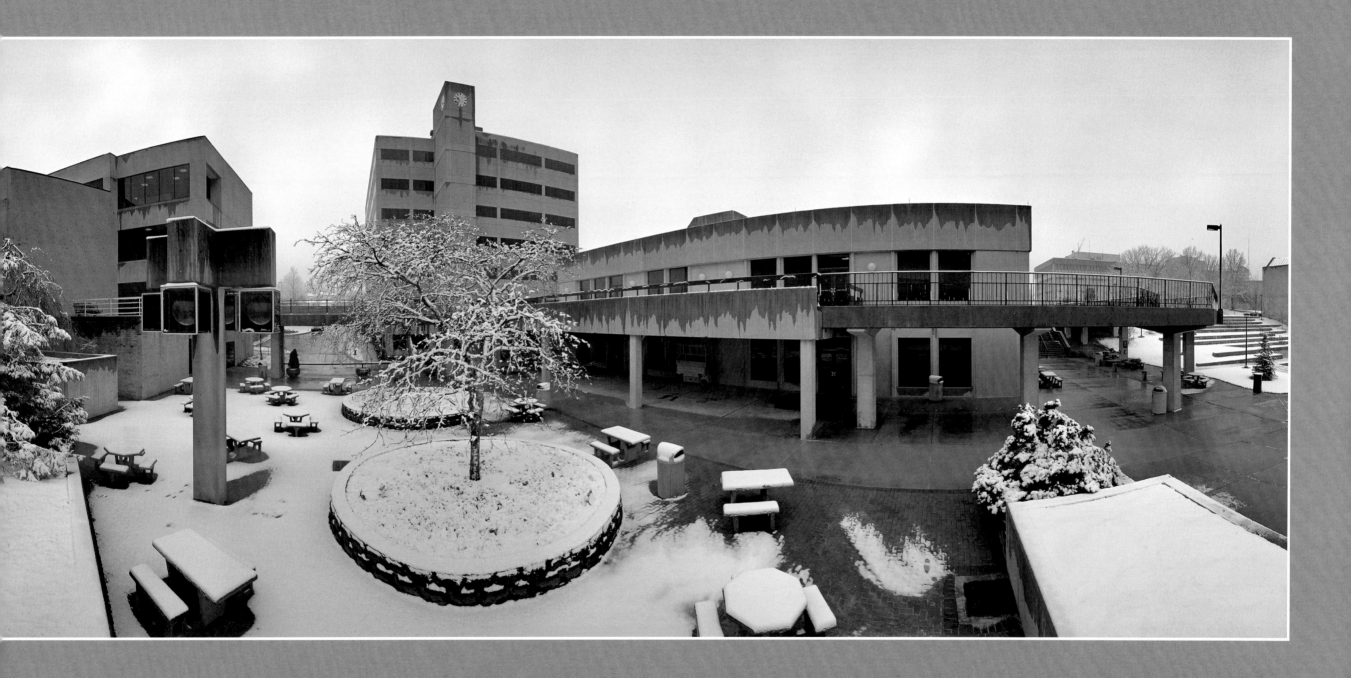

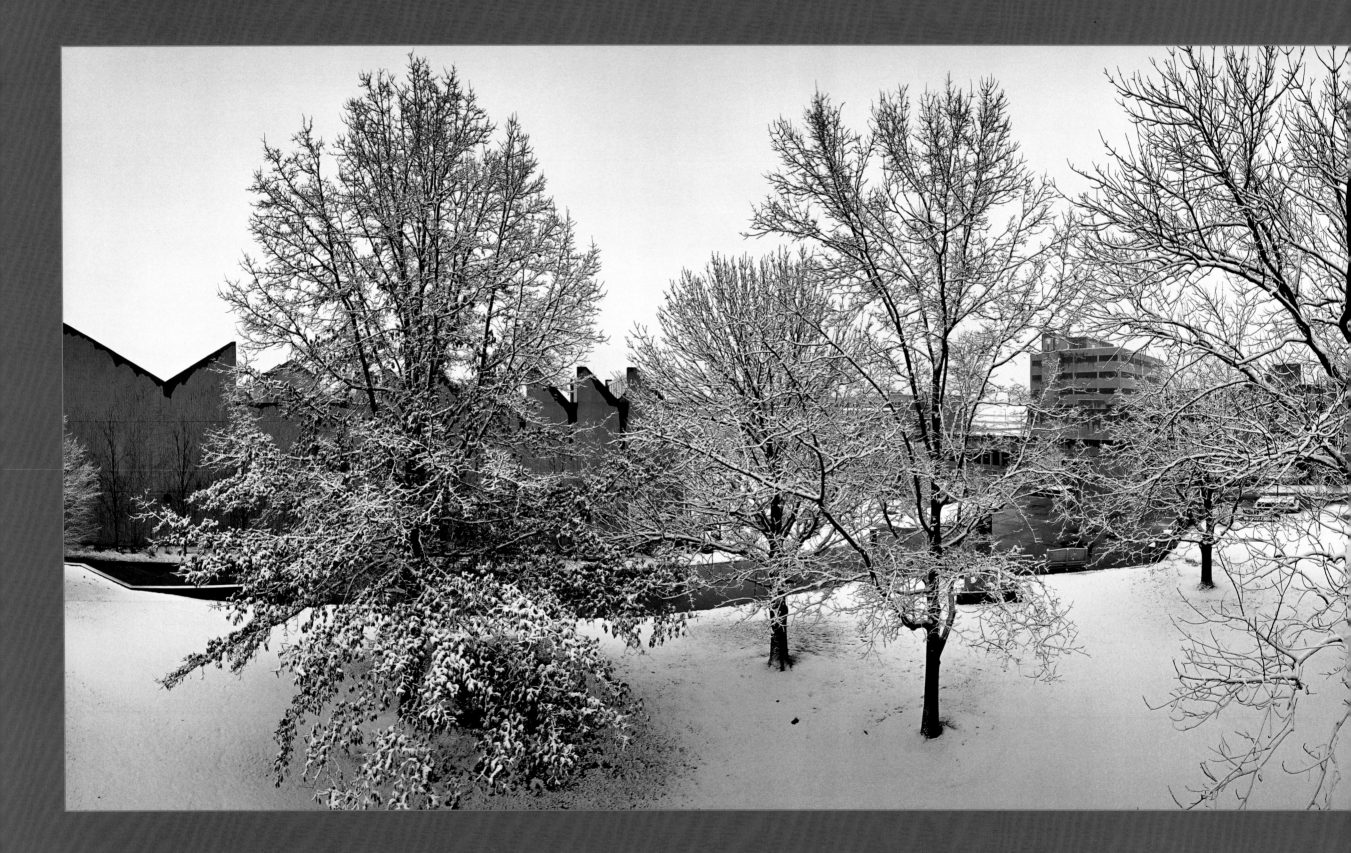

Campus center in the snow, 2010

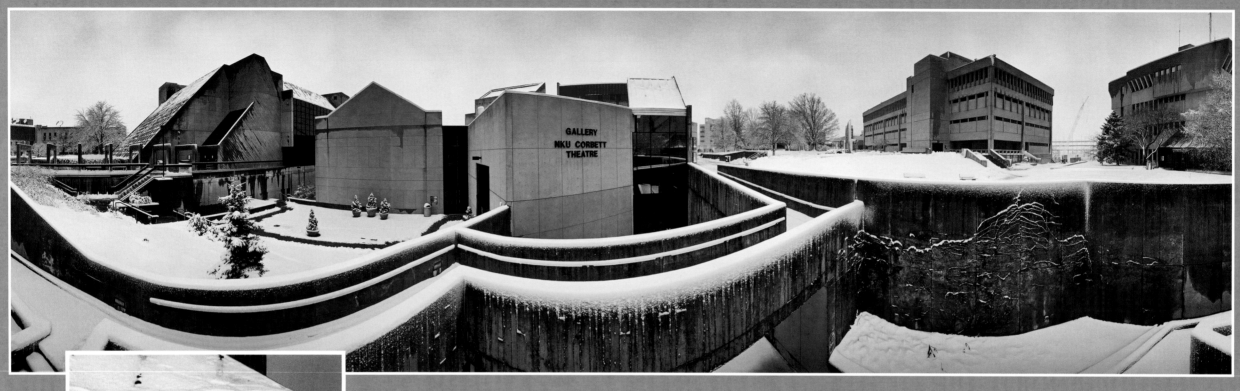

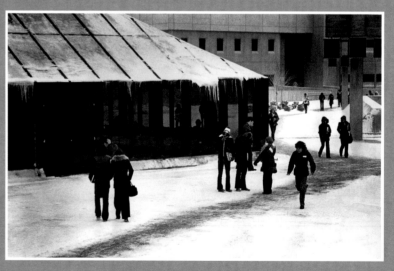

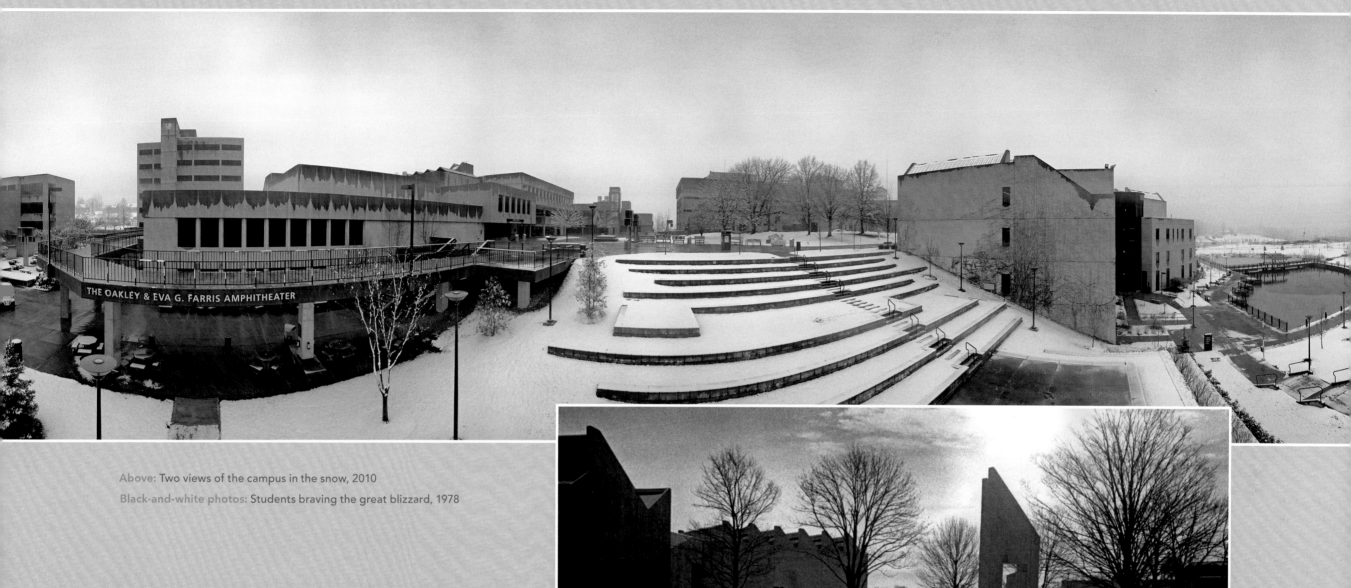

Above: Two views of the campus in the snow, 2010

Black-and-white photos: Students braving the great blizzard, 1978

THE OAKLEY & EVA G. FARRIS AMPHITHEATER

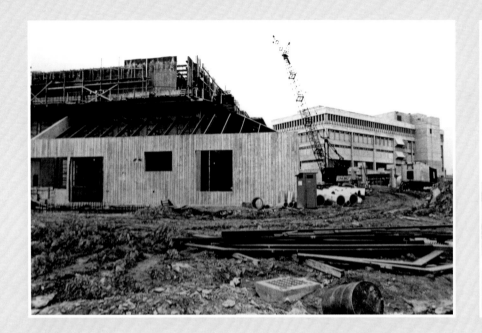

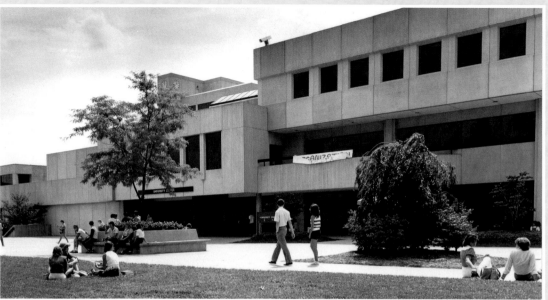

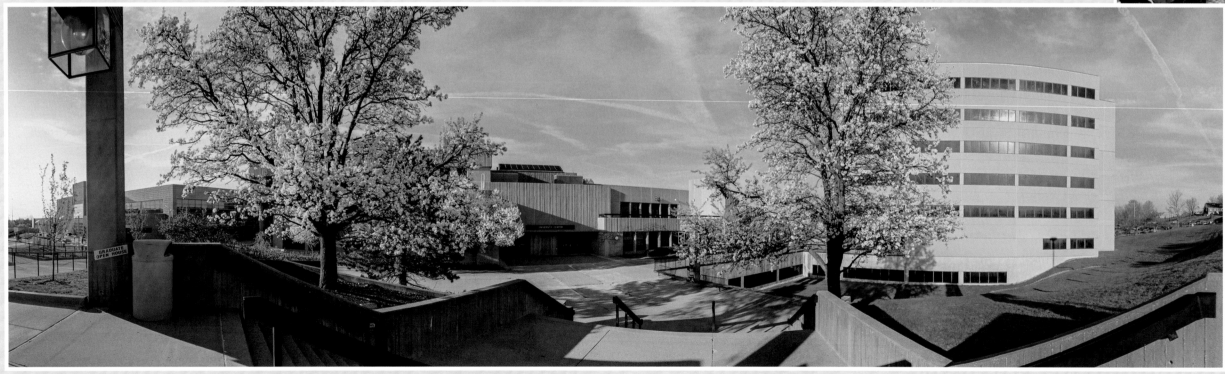

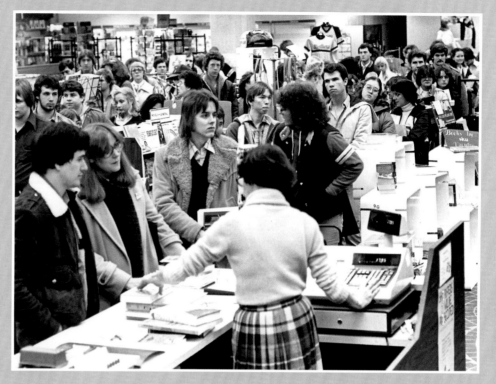

Top row (*left to right*):

University Center construction, circa 1976–77

University Center front entrance, early 1980s

Lucas Administrative Center groundbreaking ceremony inside University Center, October 18, 1979

Students congregating outside University Center's front entrance, early 1980s

The campus bookstore inside University Center on the first day of classes, late 1970s

Left: University Center, 2011

UNIVERSITY CENTER

The four-level University Center anchors the southern end of the Central Plaza, connecting that space to the picturesque Loch Norse area. The plaza level of this facility includes the 286-seat Otto Budig Theatre, and the three-story, landscaped, and skylit atrium features a cantilevered staircase to the upper levels. In 2013 a renovation rebranded the building as the home of the Student Success Center, where the first and second floors now include Career Services, Norse Advising and the Information Technology Norse Tech Bar, First Year Programs, and the Veterans Resource Station.

GROSS SQUARE FEET: 102,720

ORIGINAL COST: $5,809,447

GROUNDBREAKING: January 29, 1976

DEDICATION: October 16, 1977

ARCHITECT: Edward J. Beiting Jr., P.S.C.

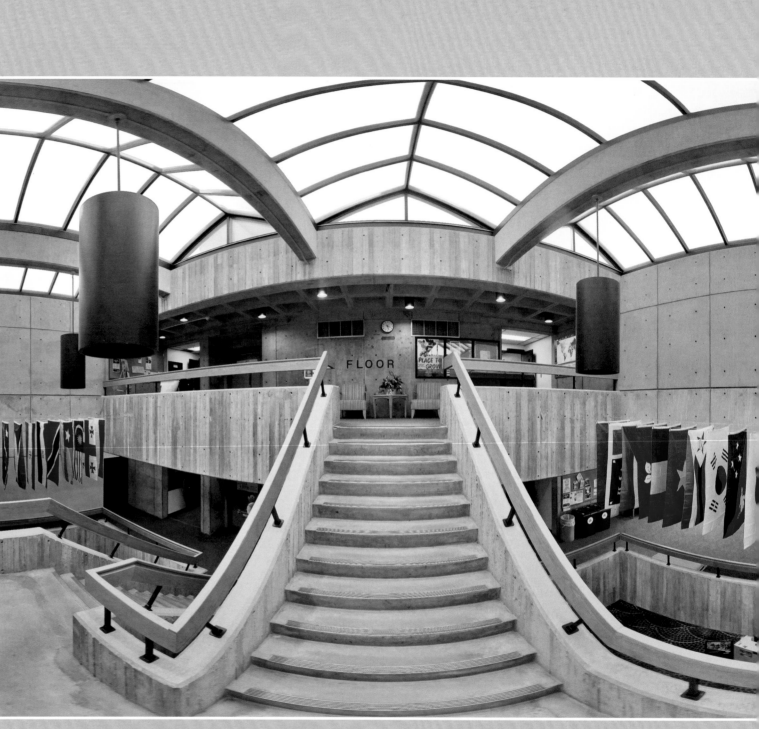

Above: University Center, 2010

Left: University Center, 1977

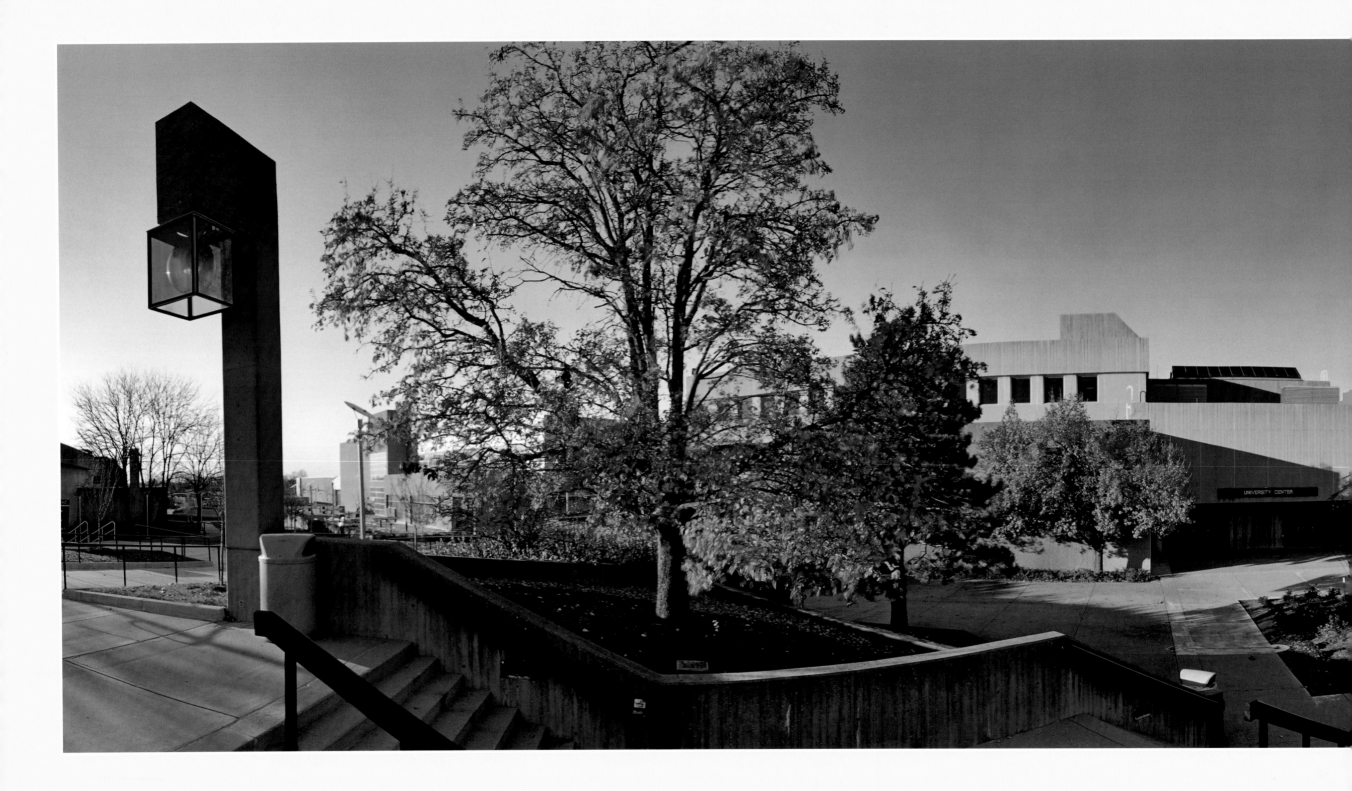

University Center, 2010

ALBRIGHT HEALTH CENTER

Albright Health Center provides classroom and laboratory facilities, as well as recreational and fitness facilities, including open gym space, an indoor track, racquetball courts, swimming pool, and fitness rooms.

GROSS SQUARE FEET: 136,324

GROUNDBREAKING: July 15, 1982

ARCHITECT: Edward J. Beiting Jr., P.S.C.

ORIGINAL COST: $9,087,489

DEDICATED: September 7, 1984

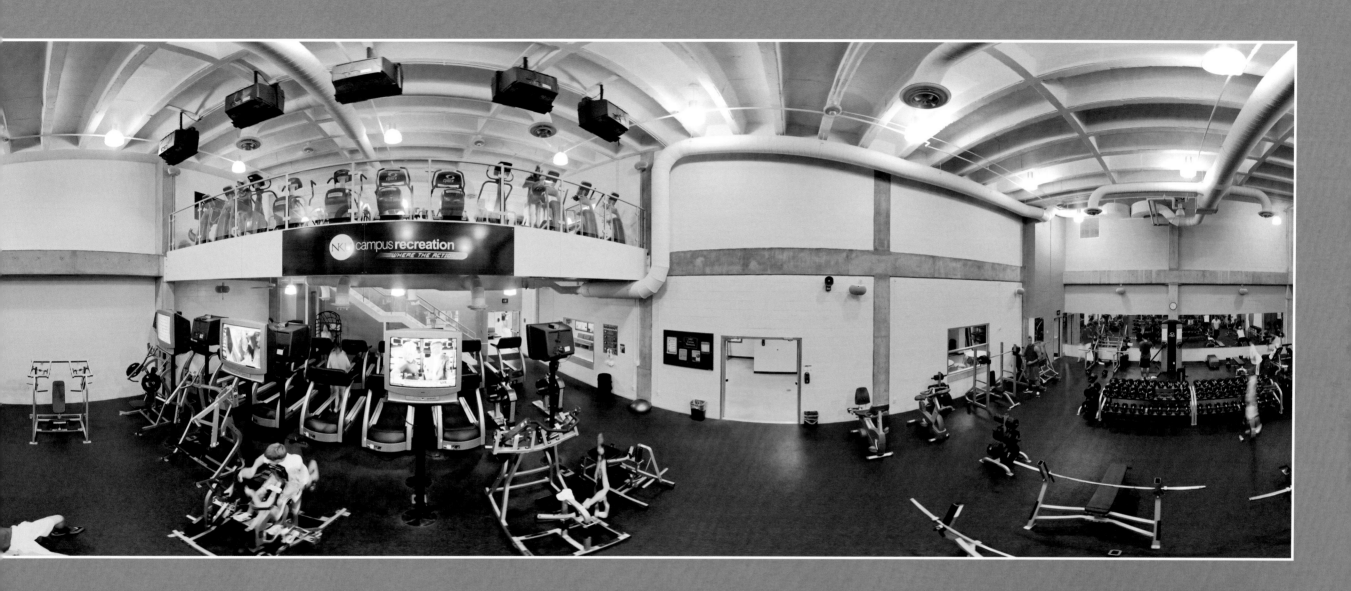

Above: Albright Health Center Fitness Room, 2010

Left: Albright Health Center, 1990s

LEON E. BOOTHE, 1983–1996

WHEN LEON E. BOOTHE, THE THIRD PRESIDENT OF NORTHERN KENTUCKY UNIVERSITY, ARRIVED IN HIGHLAND HEIGHTS, HE ALREADY POSSESSED AN IMPECCABLE ACADEMIC AND ADMINISTRATIVE RECORD. HE HAD RISEN FROM A TENURED FACULTY POSITION TO DEAN AT GEORGE MASON UNIVERSITY AND FINALLY SERVED AS VICE PRESIDENT FOR ACADEMIC AFFAIRS AT ILLINOIS STATE UNIVERSITY.

by Michael Ryan

Of perhaps equal importance, his doctoral training was in the area of U.S. diplomatic history; this academic preparation would prove to be a valuable asset in navigating the tumultuous waters of Kentucky state politics.

During Boothe's lengthy and successful tenure as president, NKU made rapid strides forward in the areas of curriculum, academic construction, and institutional change. In retrospect, these advances appear even more remarkable given the poor condition of state funding of the university. In broad terms, this meant an approximately 50 percent increase in student enrollment accompanied by a 50 percent per-capita decline in state subsidy. Or, in perhaps even starker terms, NKU's budget allocation from Frankfort was cut ten times in thirteen years. Although not peculiar to NKU—there were some difficult years throughout the country—these financial realities presented truly daunting challenges.

Despite these hurdles, on the curriculum front perhaps the most notable innovation was a vast increase in the number of international education and exchange programs that launched NKU onto a world stage, thereby providing students, faculty, and staff members with a wider range of academic and life experiences. For example, it was during this period that the Cooperative Center for Study in Britain (later expanded to the Cooperative Center for Study Abroad) brought its headquarters to NKU. Always keen both to recruit outstanding students and to enhance their personal horizons, President Boothe also won for our campus the location of the prestigious Governors Scholars Program, which provided many Kentucky students a rare glimpse into life in a major metropolitan area.

On an allied front, Boothe proceeded to be a major advocate of quality athletic programs. Because of the parsimonious state funding, these programs had suffered severe budget cuts for years. Boothe determined to improve the dire situation but insisted on setting high standards for athletes. He restored some funding, but only for the best student-athletes. He was an ardent attendee of NKU home basketball games (and, as he freely admits, occasionally an overly bellicose one), and his needed support definitely provided the foundation for the marvelous performance of our Division II athletic teams throughout the 1990s and first decade of the twenty-first century. I can personally attest that I have been fortunate enough to have had many male and female basketball players in my classes over the years and have found them to be the very personification of what *student-athlete* is supposed to mean.

Any history of Boothe's presidency would be sorely remiss if it did not include mention of his activist first lady.

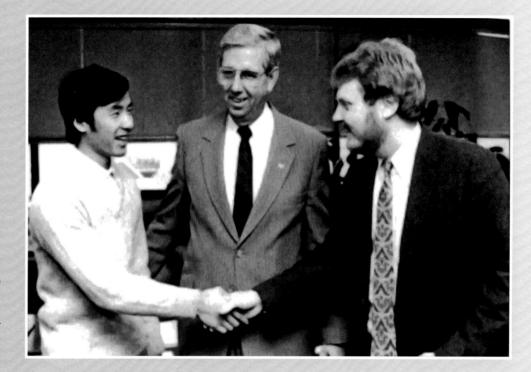

Boothe was known for increasing international student enrollment, study-abroad programs, and foreign language study. Here, Jianhua Liang became the first student from mainland China to attend NKU. Liang graduated with an MBA in 1989.

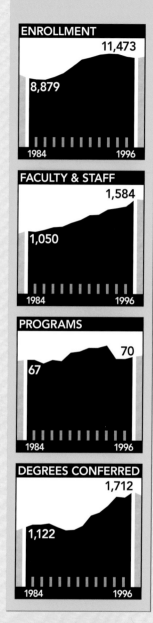

ENROLLMENT
11,473
8,879
1984 1996

FACULTY & STAFF
1,584
1,050
1984 1996

PROGRAMS
70
67
1984 1996

DEGREES CONFERRED
1,712
1,122
1984 1996

Nancy Boothe, who had the strong personality to stand up to her husband, was responsible for many of the accomplishments of NKU during these years. A *Cincinnati Enquirer* "Woman of the Year," she was happy to spread the gospel of female empowerment through her personal establishment of the Outstanding Women of Northern Kentucky Awards. She also was instrumental in turning the president's home into a true NKU house, which hosted many institutional events. Sadly, following a number of years during which Boothe served as her principal caregiver, the university lost this remarkable woman in 1996, following a lengthy struggle with multiple sclerosis.

It was also during Boothe's presidency that a number of new buildings were added to a campus that was drastically stretched for space. He presided over the dedication of the Albright Health Center and the construction of the Applied Science and Technology Center (now the Business Academic Center), and he doubled the size of both Steely Library and

the Fine Arts Center. In an entirely new emphasis, residential housing for students began to blossom during these same years. Boothe foresaw that the components of an educational experience could include a valuable sampling of on-campus life for both local and out-of-area students. This initiative has now expanded to approximately 1,800 students living in what is appropriately named the Leon E. Boothe Residential Village.

Furthermore, because of the lack of state funding, a number of creative solutions had to be implemented to ensure quality growth. During Boothe's presidency, the university undertook its first capital campaign, which greatly increased its endowment to $18 million. These private monies allowed NKU to expand in many areas, such as the creation of Greaves Scholarships, and they partly funded the construction of the performance auditorium in the Fine Arts Center. In addition, NKU developed the Foundation Research Park, constructed the beautiful baseball field, and built a new ceramics and sculpture studio. Of importance to the local economy, the

business incubator was founded and over the years has provided the impetus to a number of companies that have added to the local community. Roadways around the university were improved, and especially critical was the addition of the now-taken-for-granted exit from and entrance to Interstate 275, which greatly facilitated traffic flow on campus.

All presidents are faced with the necessity of institutional change as a university grows and evolves. One of the less exciting but extremely significant arenas of development included the creation of a separate college of business and the establishment of a school of education. Ironically, given the vagaries of Kentucky politics, perhaps a supreme victory for NKU was the fact that President Boothe played a

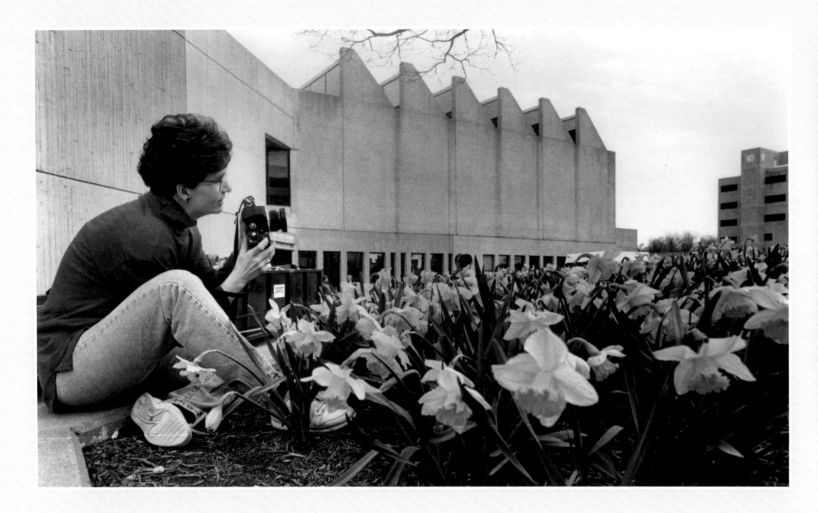

Above: Fine Arts Center painting studio, late 1970s or early 1980s

Left: A student photographer outside the Fine Arts Center, late 1980s or early 1990s

principal role in preserving Chase College of Law at a time when the signs boded ill for its continuance. Fortunately, with the support of many community leaders, this invaluable addition to NKU's educational opportunities was preserved.

Even after leaving the presidency in the late 1990s, Boothe continued to serve NKU in his original professional role as a tenured professor of history. Always an affable and valued colleague, he proved extremely popular with students and never shirked any faculty obligation, no matter how

menial the task. His presence definitely strengthened our offerings in his special area of U.S. diplomatic history.

It is impossible to address adequately in a brief essay the presidential legacy of a person who served NKU with dedication and conviction for thirteen years. Nevertheless, it must be emphasized that Boothe endeavored indefatigably to expand and enhance the university's image and community outreach throughout the region. In countless meetings, speeches, recruiting ventures—and, yes, even an

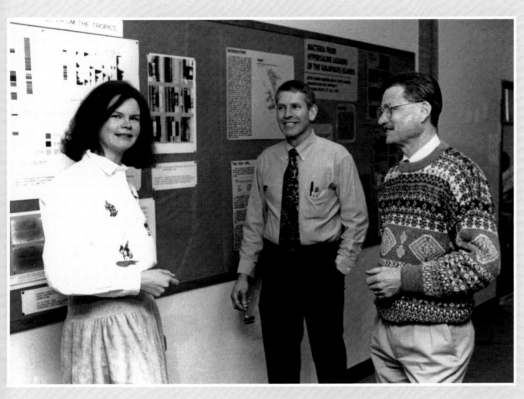

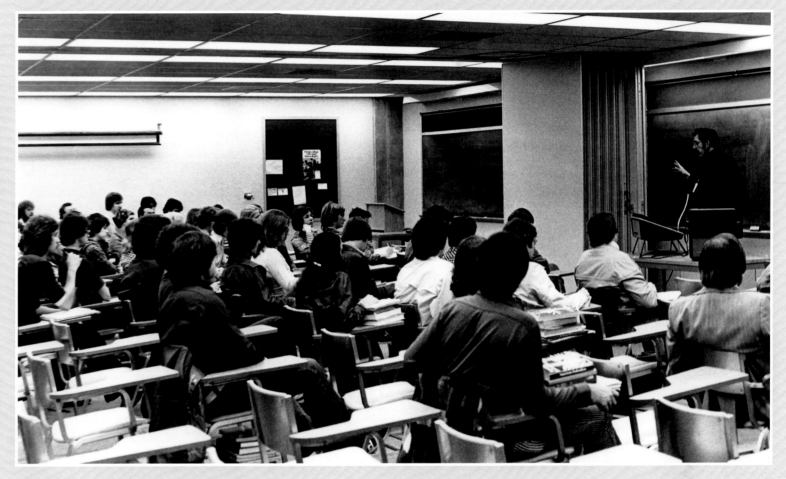

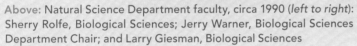

Above: Natural Science Department faculty, circa 1990 (*left to right*): Sherry Rolfe, Biological Sciences; Jerry Warner, Biological Sciences Department Chair; and Larry Giesman, Biological Sciences

Right: Founders Hall classroom, late 1970s or early 1980s

appearance on *The Bob Braun Show*—he consistently put NKU's best foot forward. And on a personal level, Boothe, a longtime civil rights advocate, strove to advance both racial and gender equality among students, staff, faculty, and his own administration.

Today Boothe lives happily in the local area with his wife, Karen. Despite his still devoting many hours to serving on boards and recruiting for NKU, he and Karen spend much of their time traveling the world, visiting with their combined

seven children, and doting on seventeen grandchildren. This would seem a fitting reward for a true professional dedicated to the betterment of the academic world and the larger community.

W. Michael Ryan, an emeritus professor of history, taught the subject at NKU for twenty-eight years.

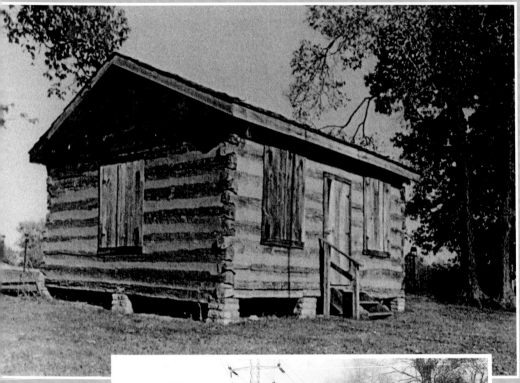

Above: Gosney log cabin and dedication ceremony, November 5, 1983. The cabin was placed on the campus by President Steely as a reminder of how far education in Kentucky has come. The cabin is undergoing renovation to serve as a learning center for several disciplines.

Students congregating on campus, late 1980s (*left*) and 1993 (*right*)

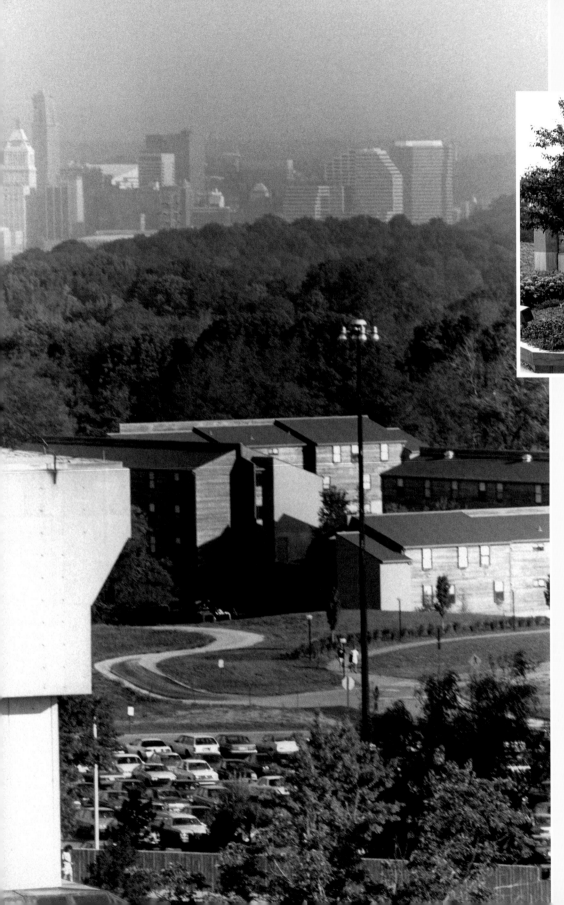

Above: Commonwealth Hall, circa 1980

Left: Kentucky and Commonwealth halls, 1980s

Right: Students and their families hauling their possessions into their new homes on move-in day, 2000 (*top*) and 2013 (*bottom*)

Opposite page:

Left: Move-in day, 2000

Far right: Students hanging out in their University Suites residence hall, 2013

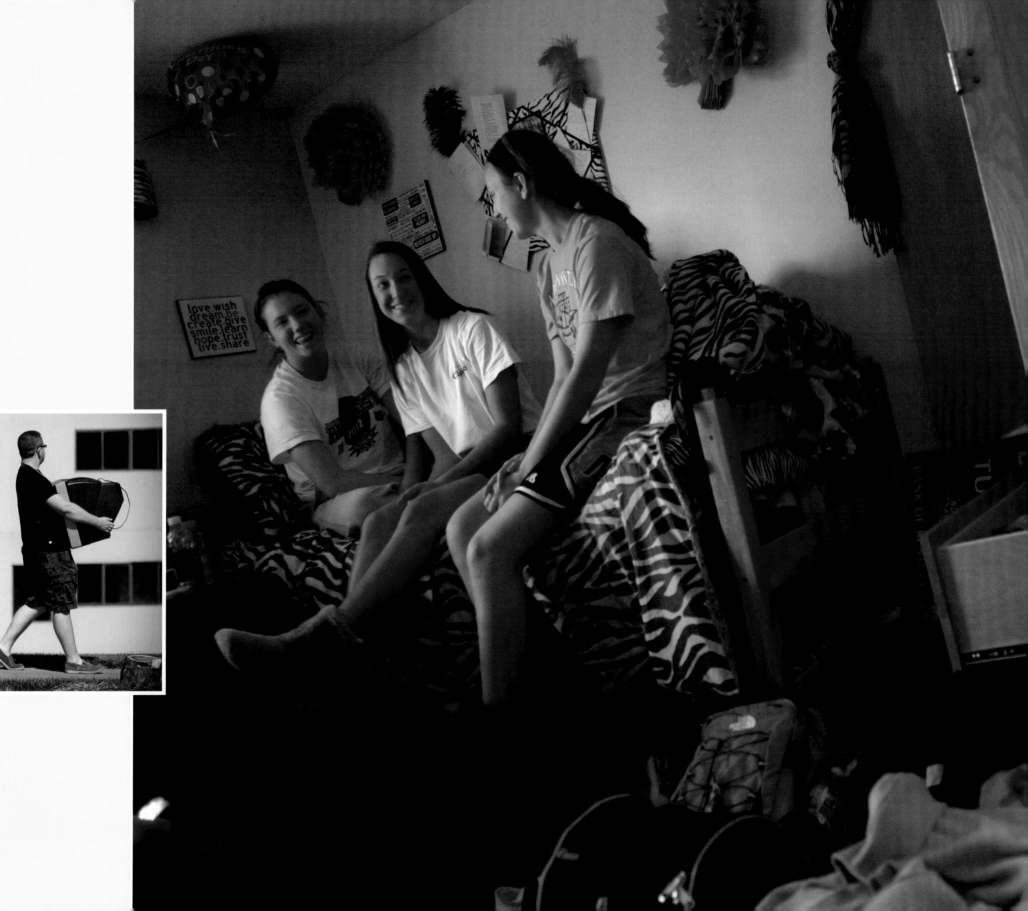

Left: Business Academic Center, circa 2005

Below: Business Academic Center classroom, 2009

Right: Business Academic Center student lounge, 2009

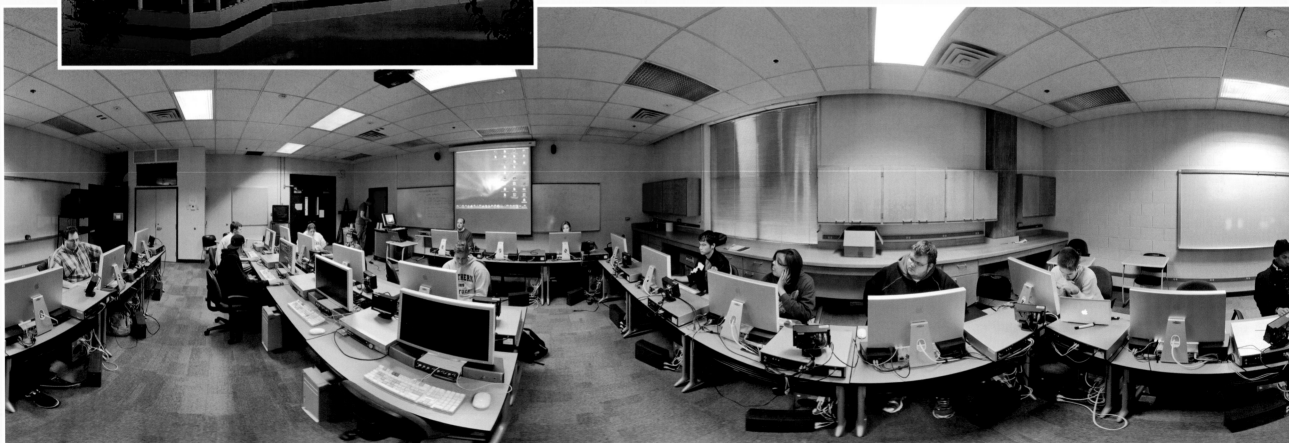

BUSINESS ACADEMIC CENTER

The Business Academic Center was the first facility to be constructed under phase one of the university's 1987 master plan. This academic facility is characterized by a two-story colonnade along the west side of the building, overlooking Loch Norse.

GROSS SQUARE FEET: 110,693

ORIGINAL COST: $9,984,318

GROUNDBREAKING: January 26, 1988

DEDICATED: May 15, 1990

ARCHITECT: Godsey Associates Architects

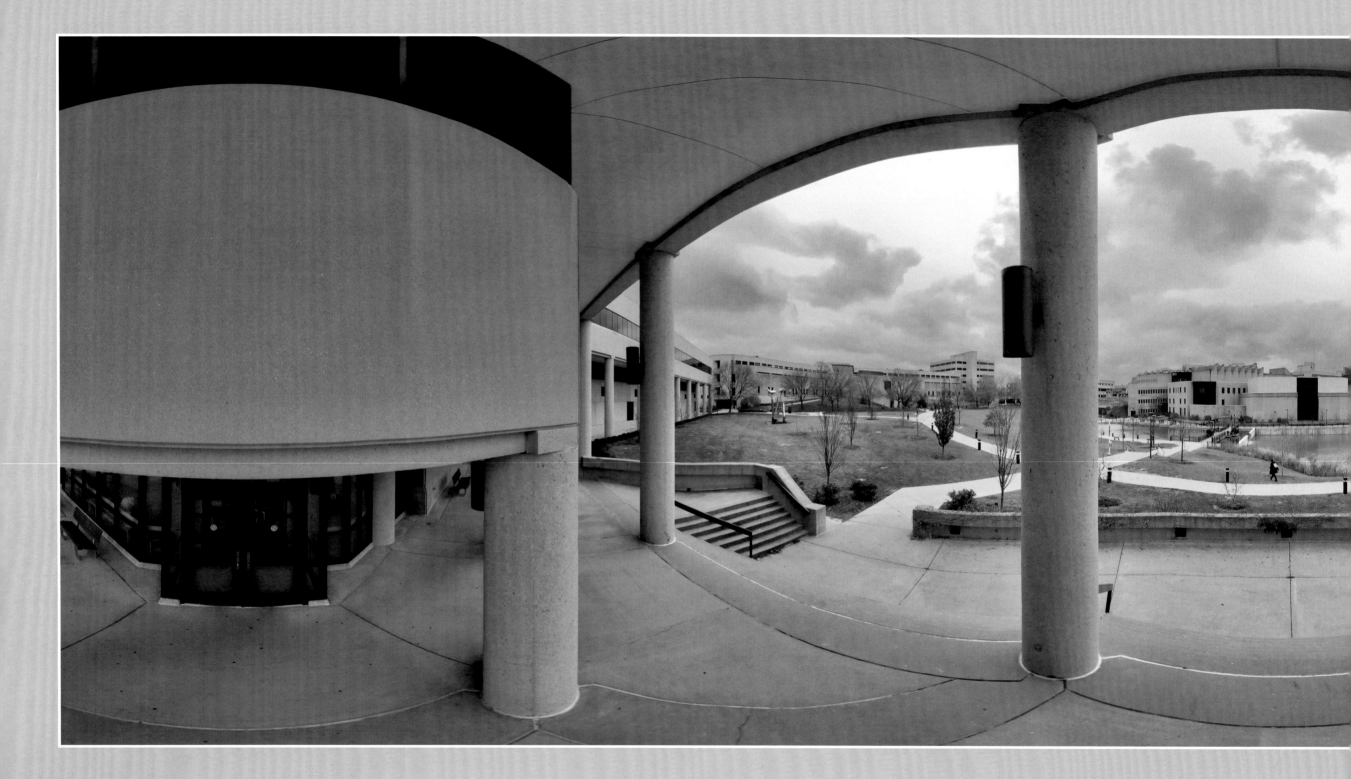

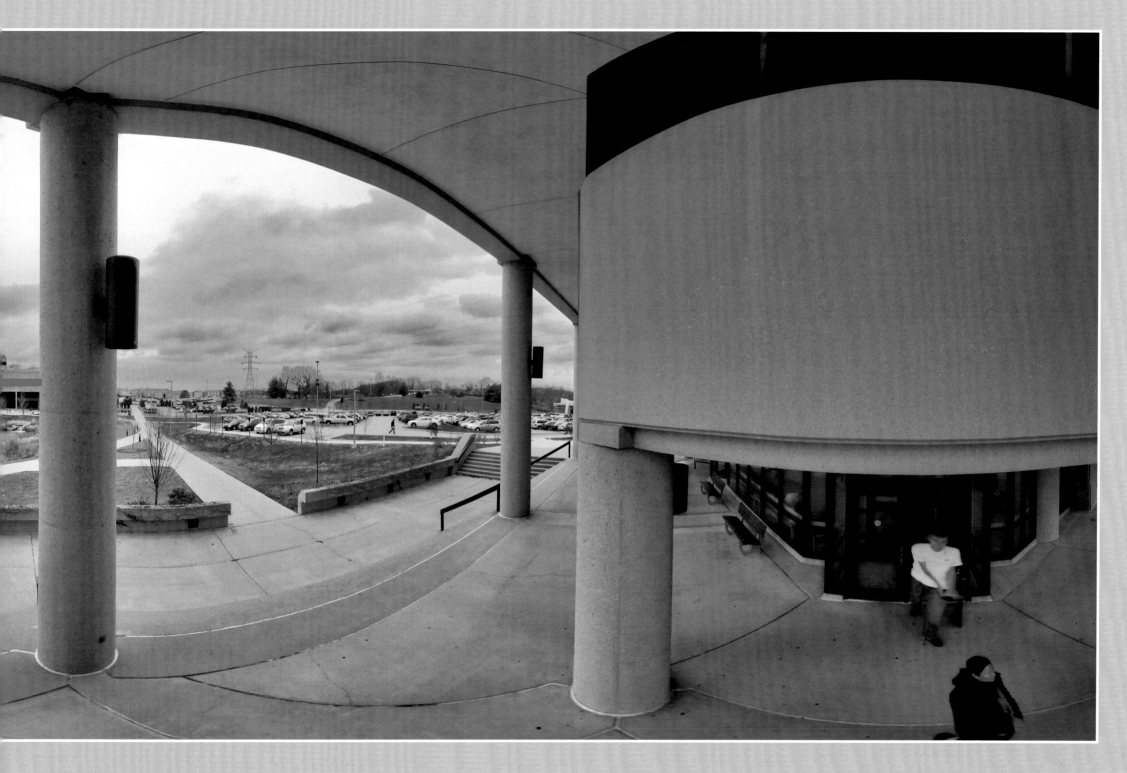

Business Academic Center entrance, 2009

JAMES C. VOTRUBA, 1997–2012

"WAIT, DR. VOTRUBA," CALLED OUT BOB ZAPP AS HE HURRIED TO CATCH UP WITH JAMES C. VOTRUBA, WHO WAS WALKING QUICKLY DOWN THE CORRIDOR. MOMENTS EARLIER, VOTRUBA HAD CONCLUDED HIS INTERVIEW WITH THE 1997 PRESIDENTIAL SEARCH COMMITTEE. HE WAS ONE OF ABOUT TEN SEMIFINALISTS INTERVIEWED BY THE COMMITTEE AND THE ONLY ONE ZAPP FOLLOWED OUT OF THE MEETING ROOM, THE ONLY ONE WHO "KNOCKED THE SOCKS" OFF THE COMMITTEE.

by Carole Beere

"I want to talk with you for a minute," continued Zapp. The one minute extended to thirty as Mr. Zapp (chair of the Presidential Search Committee, NKU regent, and president of the Bank of Kentucky) described the region and the opportunities that awaited the next president of NKU. Zapp was clearly convincing: when offered the presidency, Votruba accepted.

Thus began the history of the fourth and longest-serving president of Northern Kentucky University.

James C. Votruba's fifteen-year presidency (1997–2012) was characterized by optimism and hope, energy and resolve. During the Votruba years, NKU passed out of its adolescence toward full maturity. Votruba would be the first to acknowledge that he did not do it alone. He built on the achievements of those who came before him, and he worked collaboratively with his vice presidents, NKU's faculty and staff, and the broader community in northern Kentucky, Cincinnati, and Frankfort.

From the inception of his presidency, Votruba was committed to forging a shared agenda for NKU's future. Within weeks of taking on his new role, he initiated Vision, Values, and Voices (VVV), a strategic planning process that called on faculty, staff, students, and members of the external community to help chart the university's future. He repeated VVV every five years, thereby ensuring broad representation in strategic planning throughout the years of his presidency.

Votruba's tenure can be described by three defining characteristics: growth, quality, and community outreach. Dramatic *growth* was apparent in almost every aspect of the university. Between 1997 and 2012, enrollment increased by about 30 percent, to 16,000 students, including significantly more students of color and more international students. Undergraduate degrees awarded grew by 76 percent; the number of bachelor-level degree programs increased by 37 percent; and the faculty count increased by 32 percent. The only area of program decline was in the associate degree offerings. With the opening of a nearby community college, NKU was able to reduce its community college mission and devote itself to being a full-fledged university. The number of master's programs more than tripled; graduate enrollment more than doubled, as did the number of master's degrees awarded; and NKU added twenty-six graduate certificate programs and two applied doctoral programs. Three new colleges were created: the College of Education and Human Services, the College of Health Professions, and the

President Votruba and his wife, Rachel, at Homecoming Jam, 2007

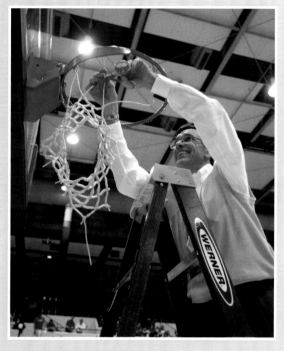

Celebrating after the women's basketball team's victory over South Dakota for the NCAA Division II Championship, March 29, 2008

ENROLLMENT
15,660
11,785
1997 2012

FACULTY & STAFF
2,121
1,550
1997 2012

PROGRAMS
91
71
1997 2012

DEGREES CONFERRED
2,880
1,640
1997 2012

College of Informatics, one of the first such colleges in the nation. All three were created to address the region's need for high-performing professionals to advance regional progress.

Growth was also apparent in the size of the campus and its physical facilities. During Votruba's presidency, NKU's acreage increased by 29 percent to 422 acres. Building space more than doubled with the addition of two large classroom buildings (Dorothy Westerman Herrmann Natural Science Center and high-tech Griffin Hall, home of the College of Informatics); the James C. and Rachel M. Votruba Student Union, named by the students; the Bank of Kentucky Center; the Soccer Stadium; the Frank Ignatius Grein Softball Field; a new power plant; the Welcome Center; two residence halls; and three parking structures.

During Votruba's tenure, the university also expanded its intercollegiate athletics program from an outstanding NCAA Division II program to a program that would compete at the highest level of intercollegiate athletic competition, NCAA Division I.

Another area that saw growth was the NKU budget, which was $70.7 million in 1997 and increased to more than $200 million in 2012. NKU's endowment increased nearly fivefold, to more than $74 million, and grant support nearly tripled, to $9.5 million. In the later years of Votruba's presidency, NKU, like public universities throughout the country, saw repeated reductions in state funding. Despite this, with thoughtful planning and strong leadership, NKU was able to maintain its momentum.

The second defining characteristic of Votruba's presidency was an emphasis on *quality*. While growth both supported and reflected quality enhancement, the clearest manifestation of quality commitment was the adoption of higher admission standards. With the opening of the local community college, NKU was able to move from being essentially an open-admissions university to admitting only those likely to succeed. To support students, financial aid increased by 350 percent. To meet the needs of the highest-achieving students, the Honors Program and study-abroad programs were greatly expanded. The univer-

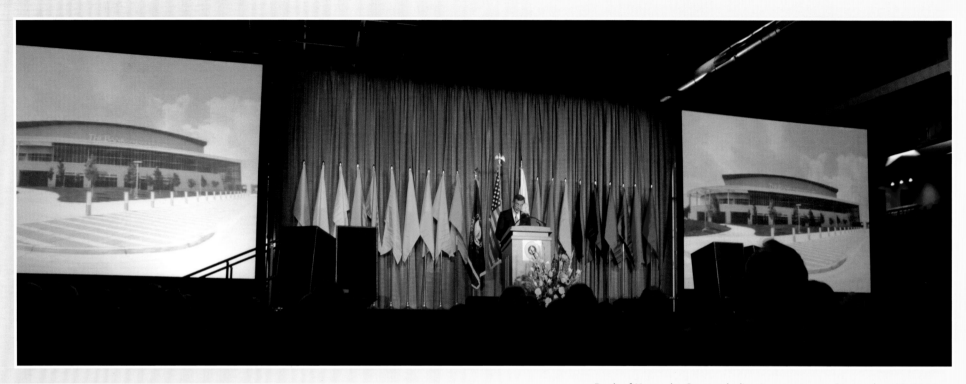

Bank of Kentucky Center dedication ceremony, September 22, 2008

sity continued its commitment to small class sizes taught by faculty committed to keeping high-quality teaching at the center of their work.

The quality of the physical environment was enhanced as well. The lake was totally renovated, and students renamed it Loch Norse. The starkness of the concrete buildings was softened by attractive and creative landscaping. The renovated plaza area provided increased outdoor seating where students could gather. The intramural fields were improved and expanded.

The third defining characteristic of the Votruba years was *outreach* to the broader regional community and

beyond. The university committed to being a full partner in supporting regional economic, social, and educational progress. The university developed partnerships with the community to address the region's priorities and created a variety of centers whose missions emphasized service to the external community. Among them were the Scripps Howard Center for Civic Engagement; the Center for Integrative Natural Science and Mathematics; the Kentucky Center for Mathematics; the Center for Applied Ecology; the Center for Applied Informatics; and the Center for Economic Analysis and Development. In response to the needs of the business community, NKU created the Metropolitan Edu-

cation and Training Center, a high-tech conference center located near the Cincinnati/Northern Kentucky International Airport.

As part of his commitment to outreach, Votruba ensured that academic programs were available when and where students needed them. At its Grant County Center, NKU provides on-site education to undergraduates living in or near Grant County. By the end of his presidency, online programs, which did not even exist in 1997, were serving more than one thousand students in fully online programs, and PACE, a special undergraduate program for adult students, enrolled more than four hundred students annually.

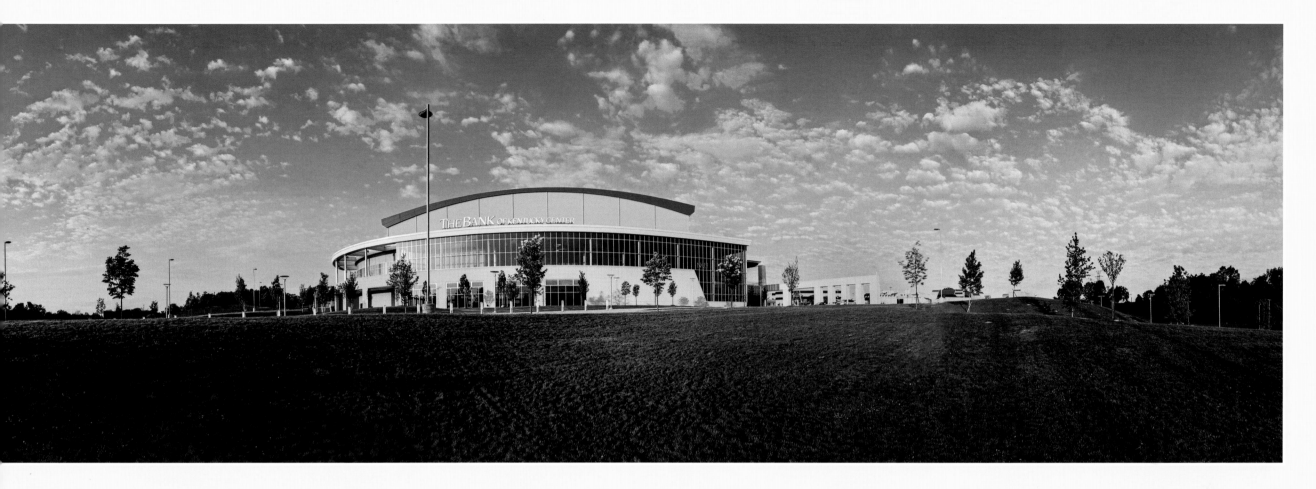

Bank of Kentucky Center, 2012

Growth, quality, and outreach, which characterized the Votruba years, led to the university's greatly enhanced reputation in the region, the state, and the nation. NKU's increased respect in the region resulted in increased donor support, including, for example, $15 million from the Carol Ann and Ralph V. Haile, Jr./U.S. Bank Foundation. The stature of the university rose in the eyes of the legislature and the Kentucky Council on Postsecondary Education. NKU became a first-choice university for students and was recognized nationally as a leader in outreach and public engagement. Clearly, President Votruba left an amazing legacy.

*Carole Beere is the former associate provost for outreach and dean of graduate studies at NKU. She began her career in higher education forty years ago as an assistant professor of psychology. After progressing to full professor, she moved into administration. Her most recent book—*Becoming an Engaged Campus: A Practical Guide for Institutionalizing Public Engagement—*was coauthored with former President James Votruba and former Provost Gail Wells and was released in March 2011.*

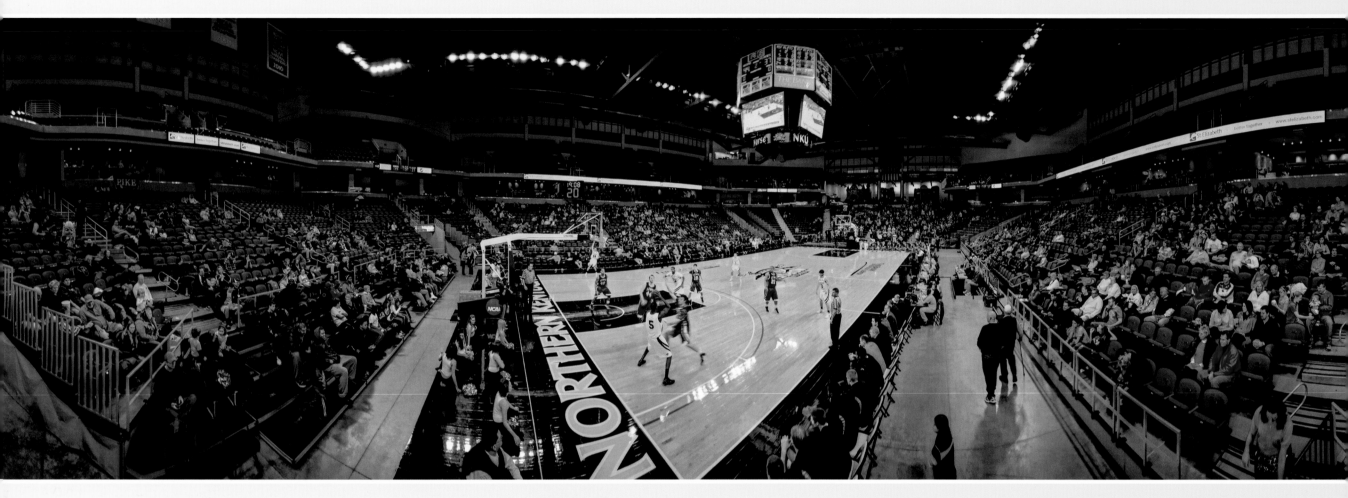

Men's basketball game at the Bank of Kentucky Center, 2012

BANK OF KENTUCKY CENTER

The Bank of Kentucky Center is a state-of-the-art sports and entertainment facility prominently located at the Nunn Drive and University Drive intersection.
This facility includes an arena accommodating up to 10,000 spectators, fourteen luxury suites, two party suites, and other amenities for sports fans.

GROSS SQUARE FEET: 243,000 **GROUNDBREAKING:** May 20, 2006 **ARCHITECT:** Gartner, Burdick, Bauer-Nilsen

ORIGINAL COST: $69,800,000 **DEDICATED:** September 22, 2008

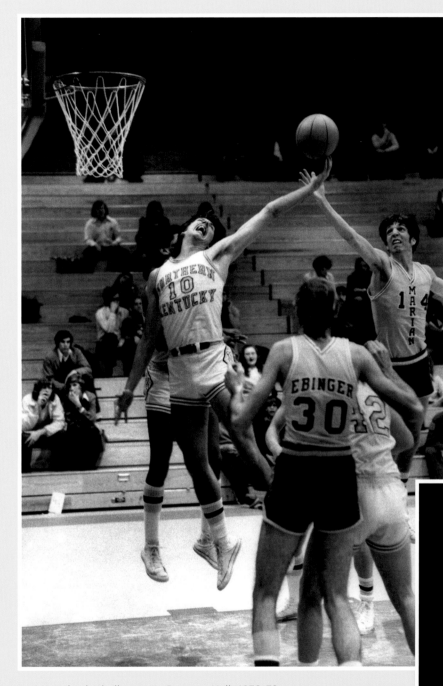

Men's basketball game in Regents Hall, 1972–73 season

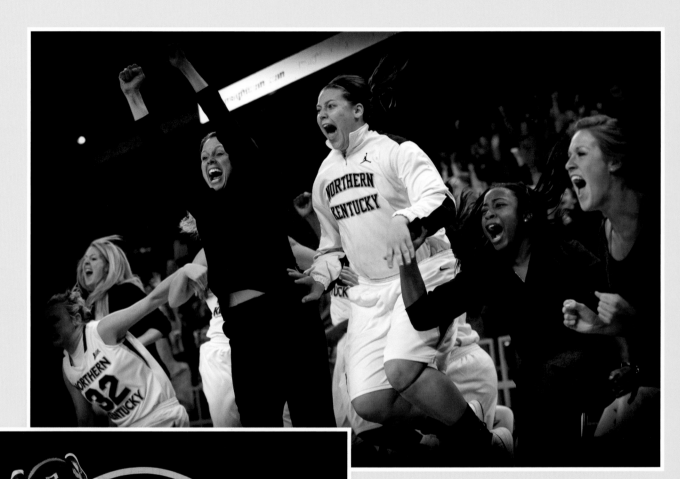

Above: Women's basketball Coach Dawn Plitzuweit and players celebrating immediately after a last-second shot clinched their first Division I victory, a 66–64 win over Youngstown State on November 27, 2012

Left: Men's basketball game versus Lipscomb at the Bank of Kentucky Center, 2014

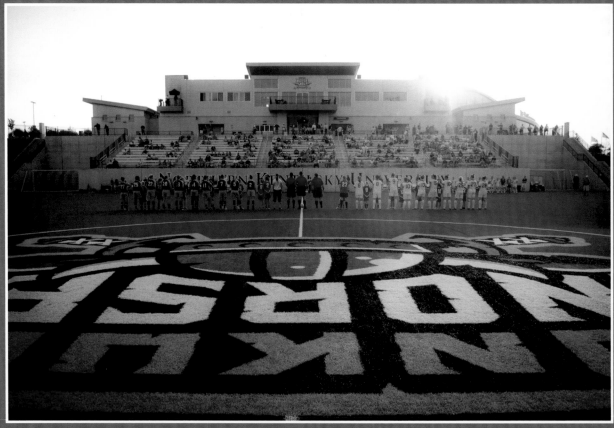

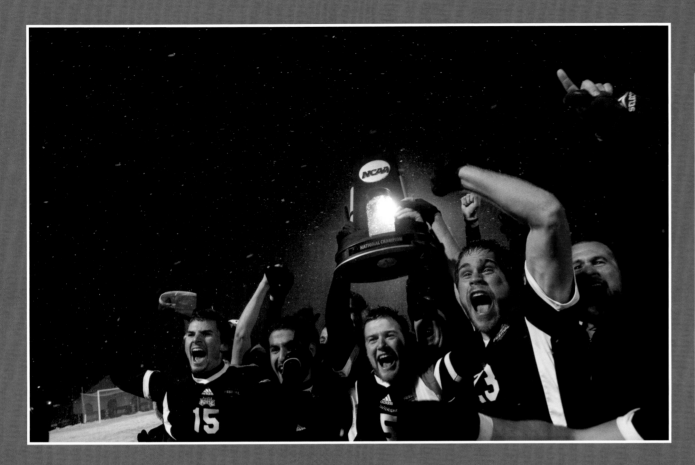

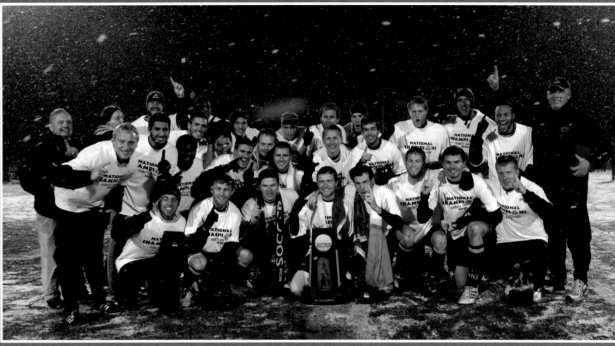

The men's soccer team celebrates winning the NCAA Division II Soccer championship, 2010.

NKU has a long tradition of athletic excellence in NCAA competition, along with exciting intramural activities. In 2012 NKU made the jump to NCAA Division I athletics.

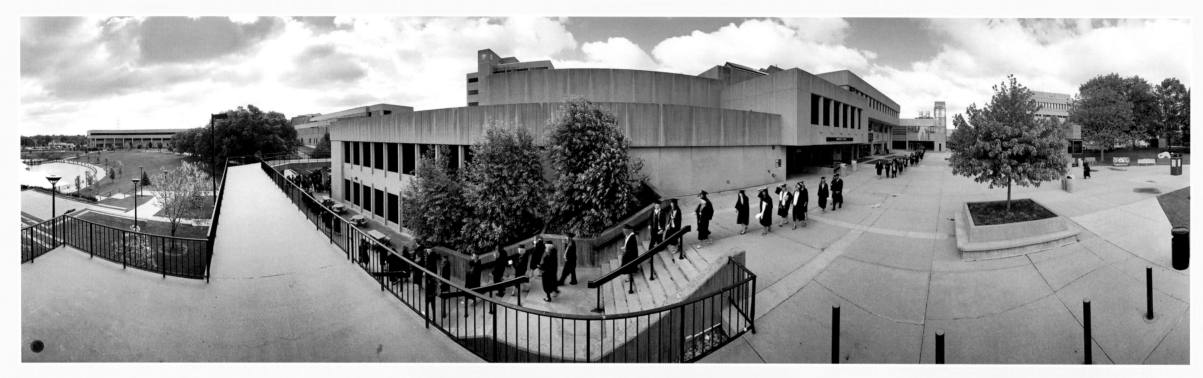

Student procession across campus during commencement, May 8, 2010

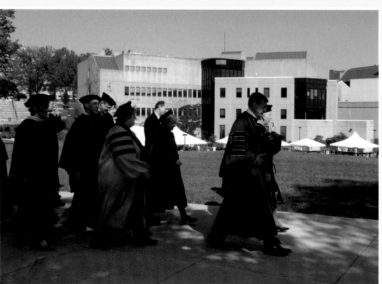

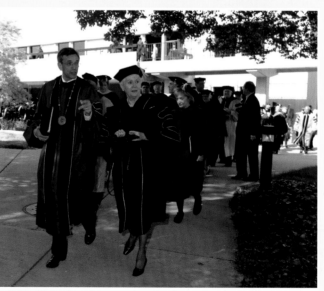

President Votruba and Ambassador Patricia L. Herbold, a Chase Law graduate, leading the student procession across campus, May 10, 2008

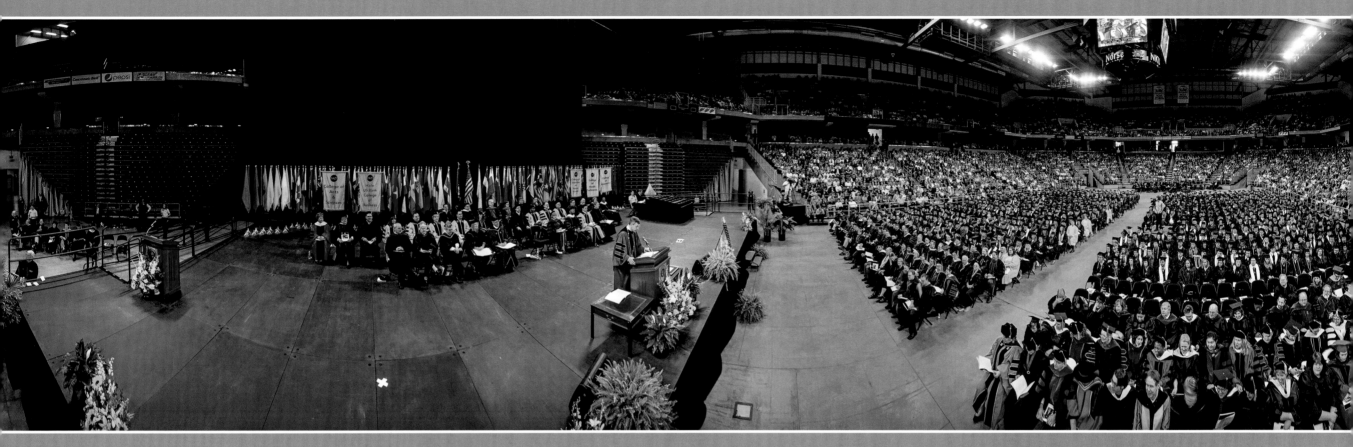

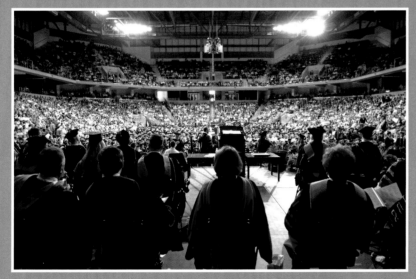

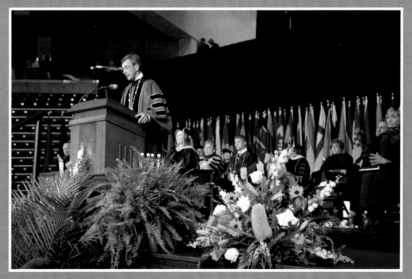

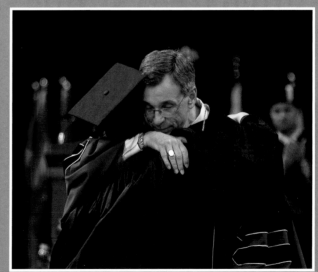

Above: The view from the stage at commencement, May 10, 2008

Top: President Votruba speaking during commencement, May 8, 2010

President Votruba speaking during commencement, May 10, 2008

President Votruba hugging a student during commencement, May 9, 2009

Left: Herrmann Natural Science Center, August 26, 2002

Below: Herrmann Natural Science Center plaza, spring 2010

Right: Herrmann Natural Science Center pendulum and entryway, 2011

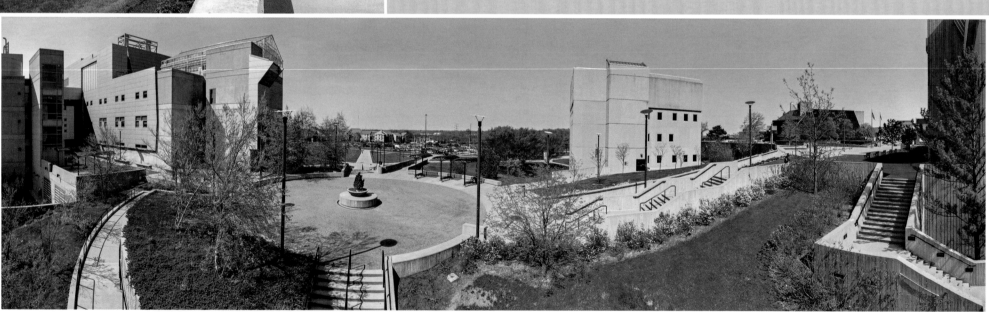

DOROTHY WESTERMAN HERRMANN NATURAL SCIENCE CENTER

The Herrmann Natural Science Center features a laboratory wing and a classroom wing joined by a large central atrium. On November 3, 2006, the Kentucky Society of Architects of the American Institute of Architects honored the Dorothy Westerman Herrmann Natural Science Center with a merit award for excellence in architectural design.

GROSS SQUARE FEET: 175,131

ORIGINAL COST: $34,710,021

GROUNDBREAKING: November 11, 1999

DEDICATED: September 20, 2002

ARCHITECT: Omni Associates

Herrmann Natural Science Center sitting area, 2011

Above: Herrmann Natural Science Center biology classroom, 2009

Left: Herrmann Natural Science Center chemistry classroom, 2009

Herrmann Natural Science Center chemistry prep room, 2009

Herrmann Natural Science Center study lounge, 2009

Above: Herrmann Natural Science Center coffee shop, 2011

Right: A student studying near an entrance to the Herrmann Natural Science Center, 2009

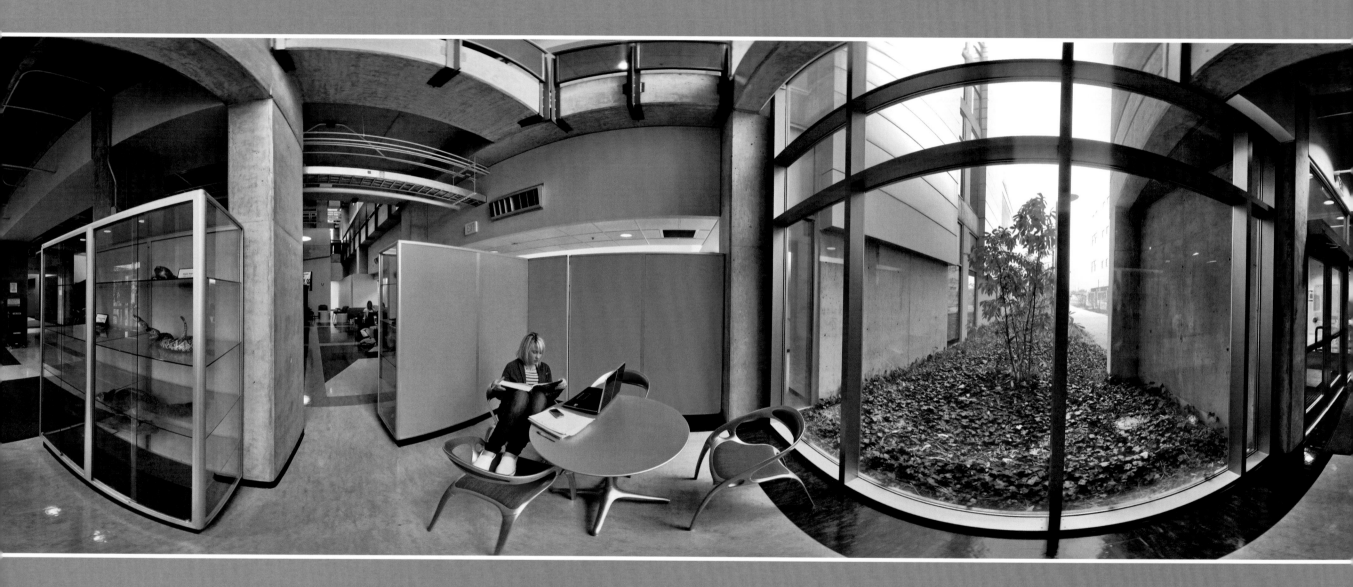

Sunset over the Herrmann Natural Science Center, 2011

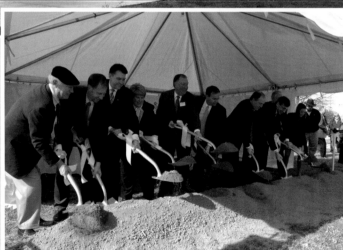

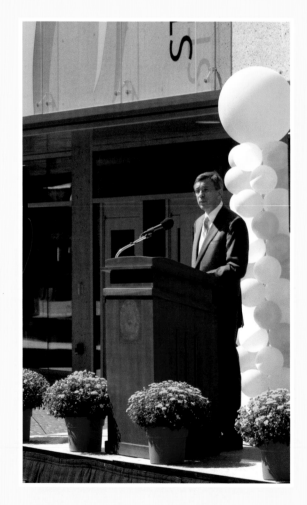

Above: Votruba Student Union groundbreaking ceremony,
February 15, 2006

Top: Votruba Student Union, 2008

Ribbon-cutting ceremony (*above*) and President Votruba speaks (*right*)
during the Votruba Student Union dedication, September 10, 2008

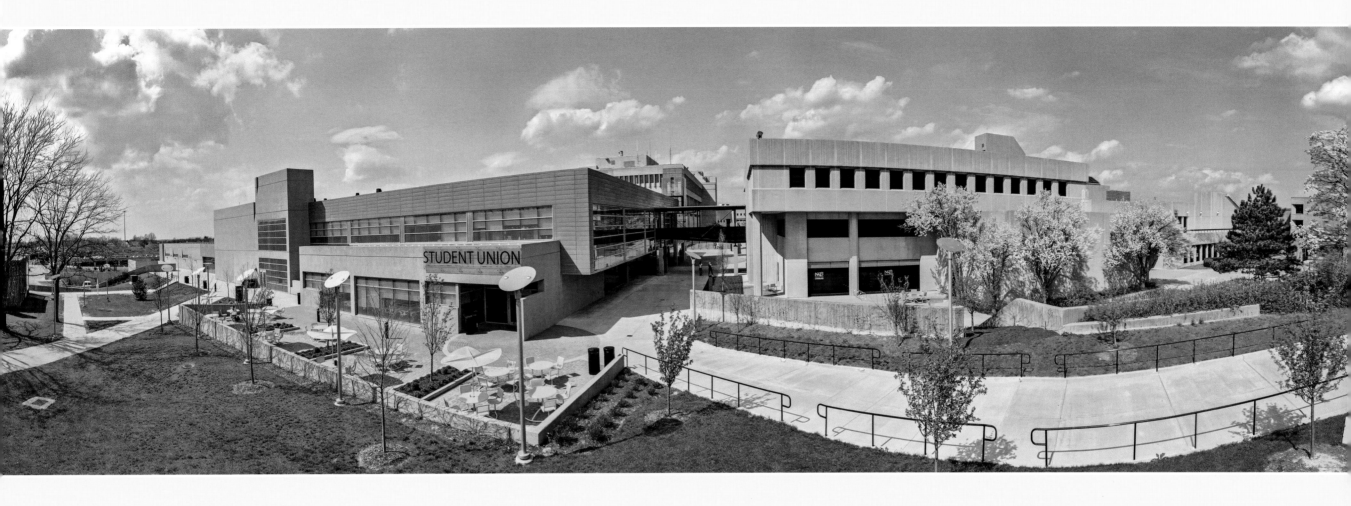

Votruba Student Union, spring 2011

JAMES C. AND RACHEL M. VOTRUBA STUDENT UNION

This building features a bright, airy atmosphere with the feel of "Main Street." The food court, the several atrium areas, and other gathering spaces are very popular student destinations that foster interaction and a sense of community.

GROSS SQUARE FEET: 144,000

ORIGINAL COST: $35,250,549

GROUNDBREAKING: February 15, 2006

DEDICATED: September 10, 2008

ARCHITECT: Omni Architects

Staircase in the Votruba Student Union, 2011

Views of the top floor of the Votruba Student Union, 2011

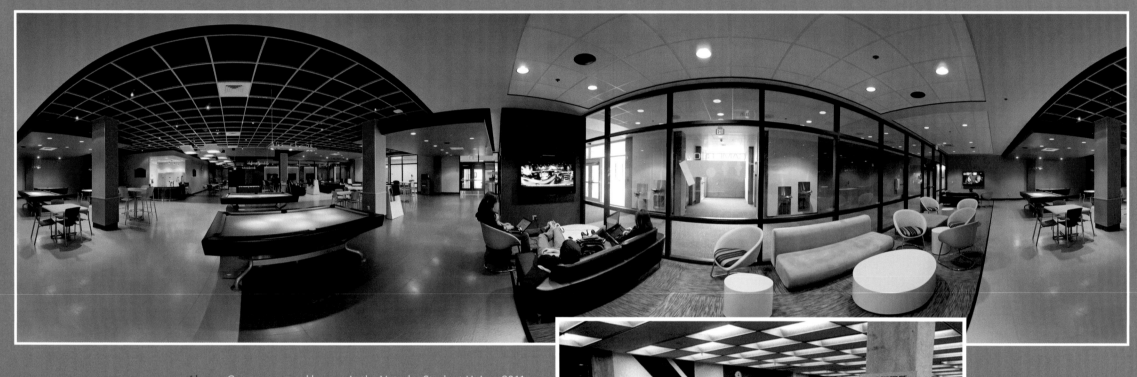

Above: Game room and lounge in the Votruba Student Union, 2011

Right: University Center game room, late 1970s

Dining options in the Votruba Student Union, 2011

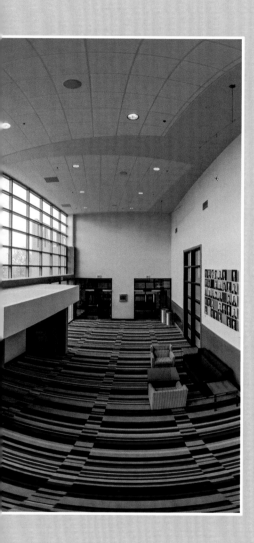

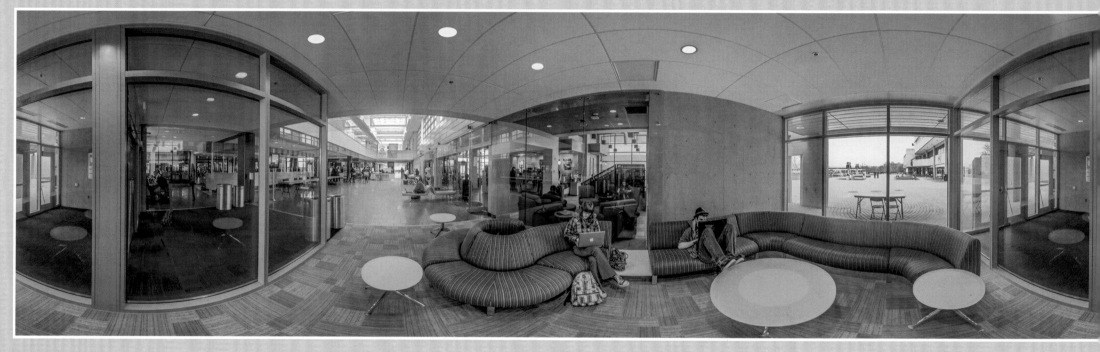

Above: Students studying near an entrance to the Votruba Student Union, 2011

Left: Votruba Student Union ballroom lobby, 2011

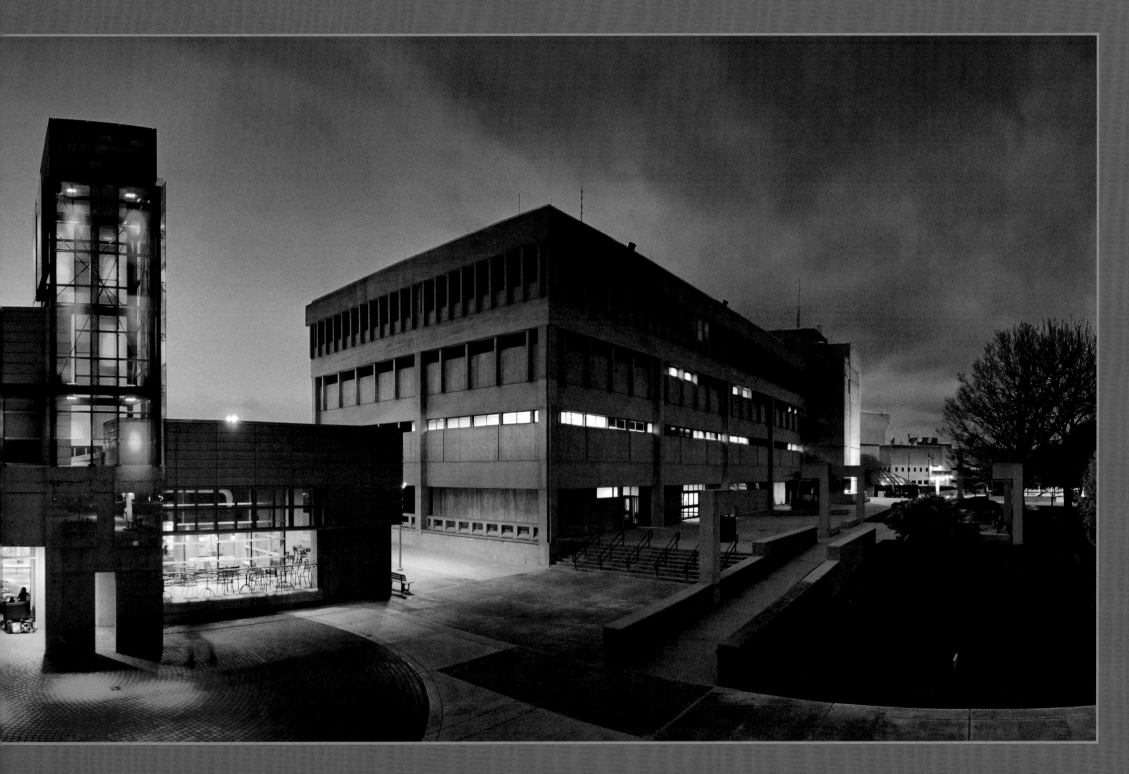

Votruba Student Union at night, 2011

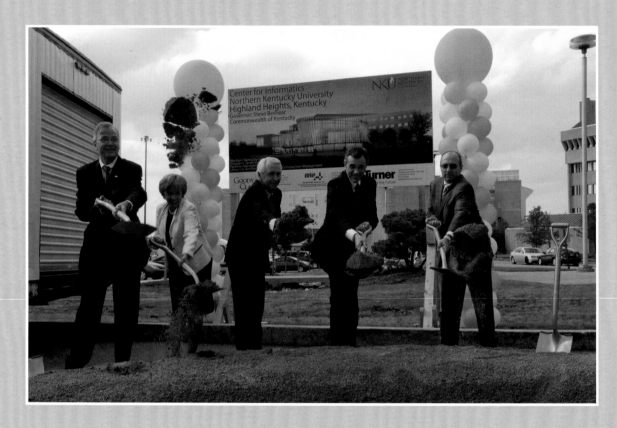

Above: Griffin Hall groundbreaking ceremony, May 28, 2009

Right: Griffin Hall at sunset, 2011

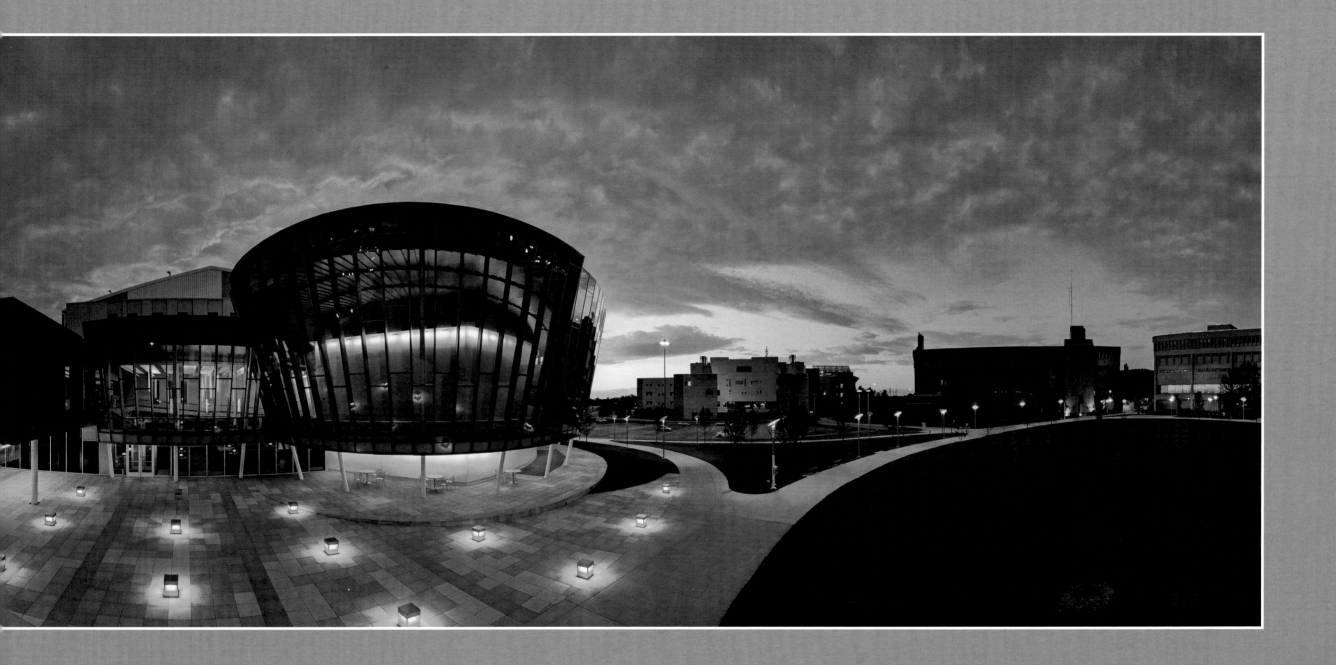

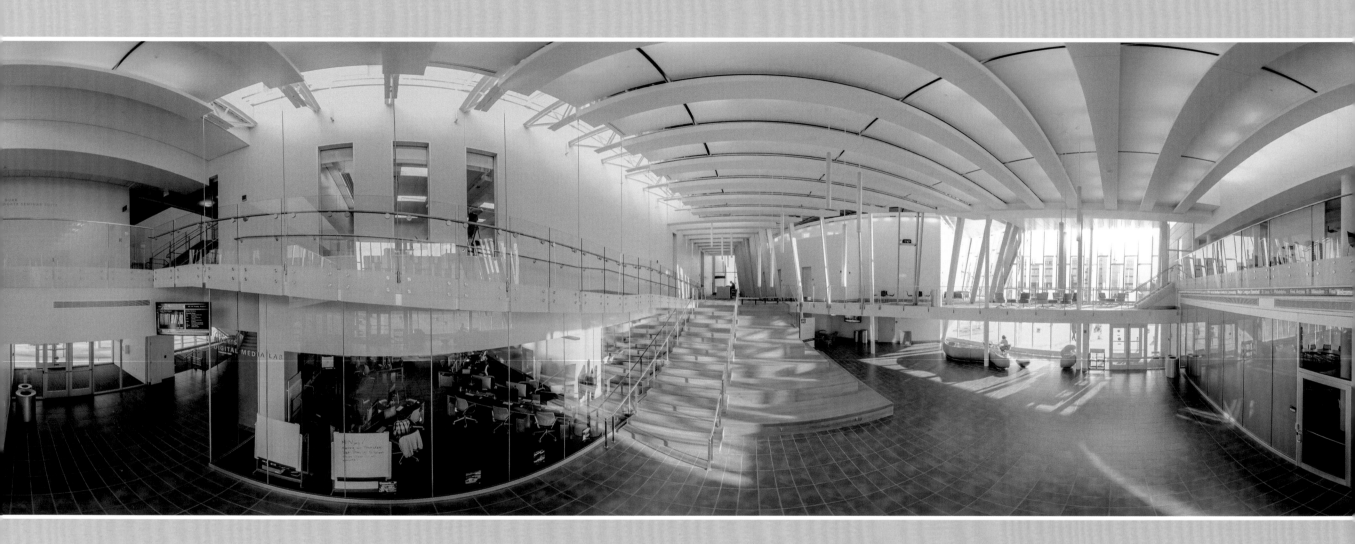

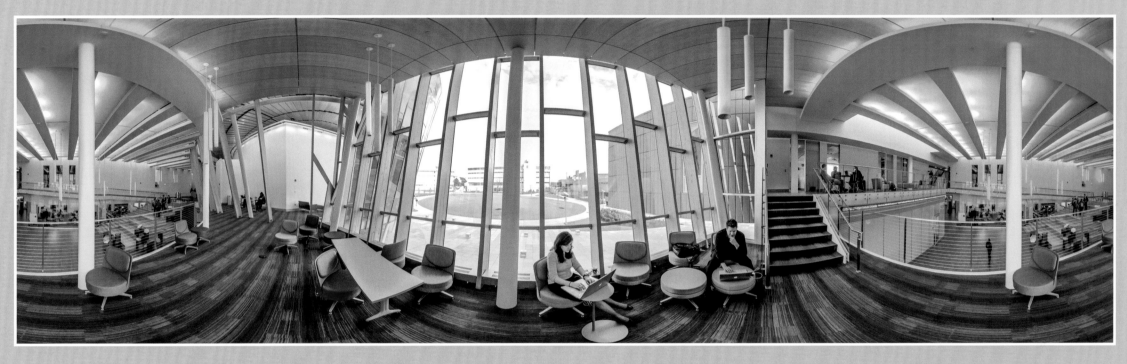

Above: Griffin Hall third-floor sitting area, 2011

Left: Griffin Hall lobby, 2011

GRIFFIN HALL

Griffin Hall includes classrooms, computer labs, a digitorium, television studios, control rooms, teaching labs, research spaces, a CAVE (computer-assisted virtual environment), offices, and support spaces.

GROSS SQUARE FEET: 63,262

GROUNDBREAKING: May 28, 2009

ARCHITECT: Goody Clancy

ORIGINAL COST: $46,877,471

DEDICATED: October 10, 2011

Above: Griffin Hall lobby, 2011
Right: Griffin Hall third floor lobby overlook, 2011

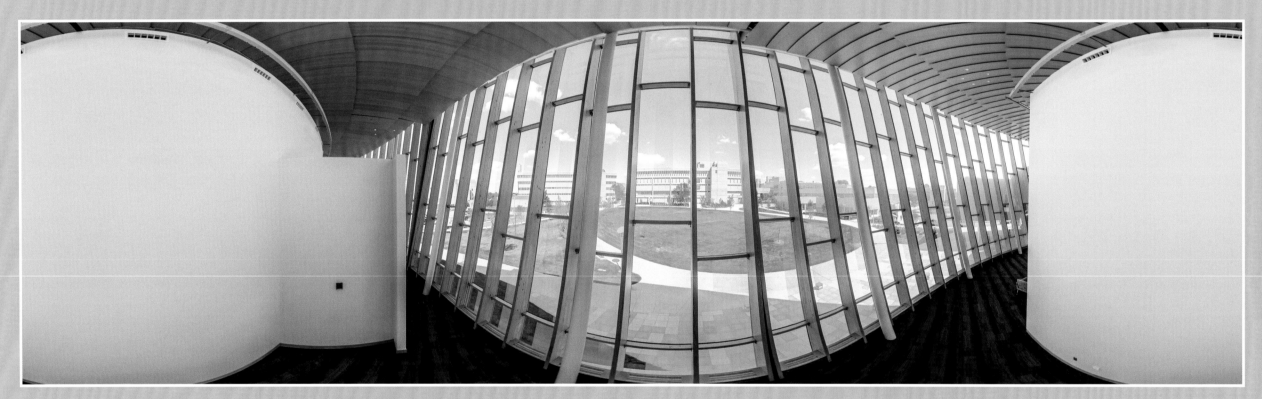

A view of campus from the third floor of Griffin Hall, 2011

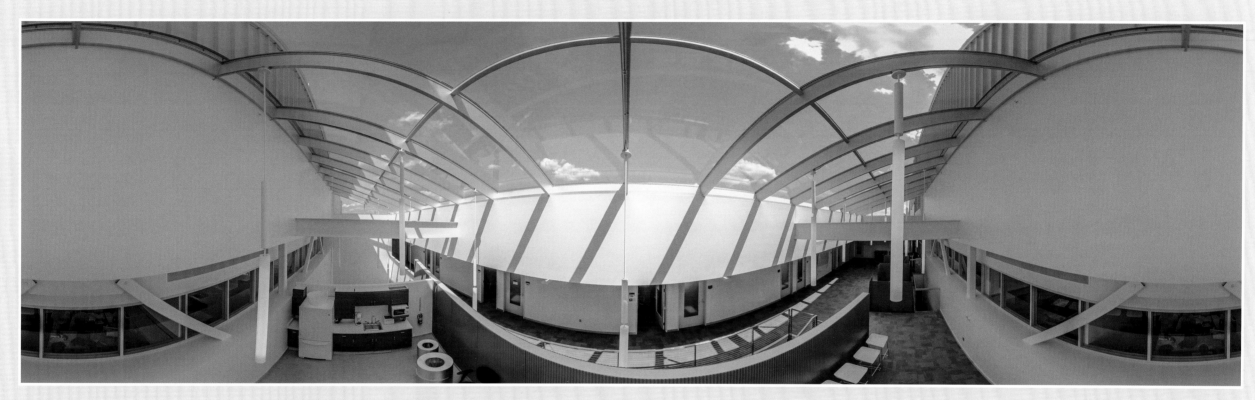

A skylight above the fifth floor of Griffin Hall, 2011

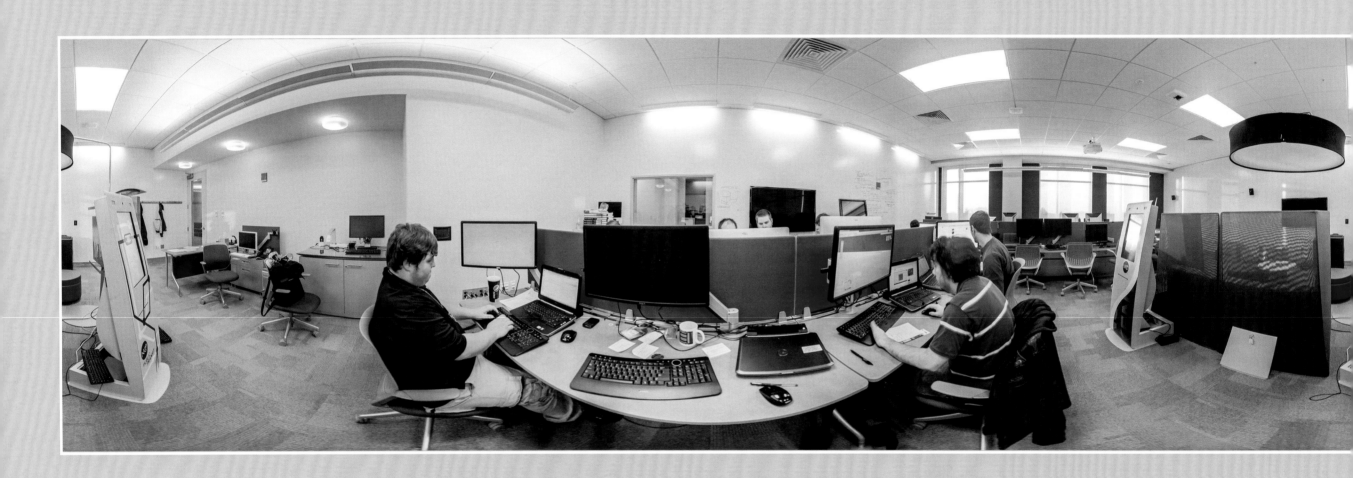

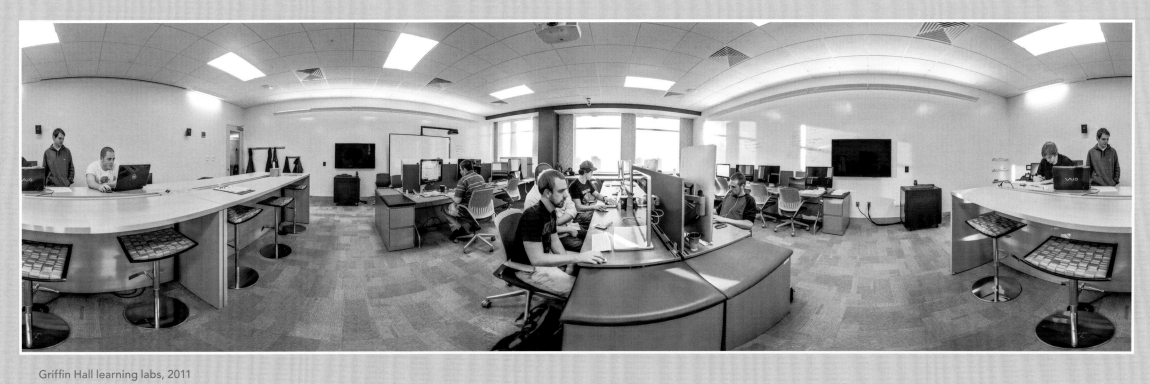

Griffin Hall learning labs, 2011

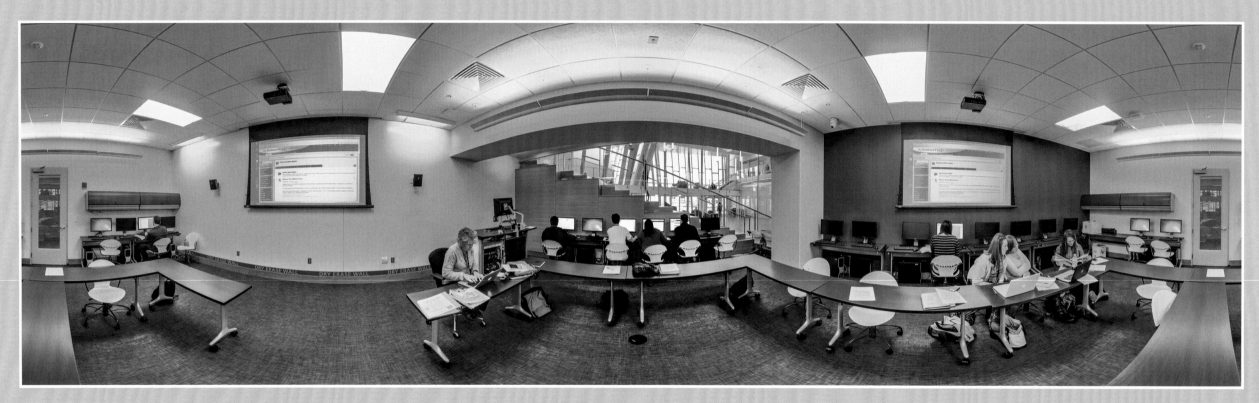

Griffin Hall smart classroom, 2011

Griffin Hall Audio and Video Control, 2011

A view of campus from the Griffin Hall entrance, 2011

GEOFFREY S. MEARNS, 2012–

ON APRIL 17, 2012, GREAVES CONCERT HALL WAS FILLED WITH FACULTY, STAFF, STUDENTS, AND COMMUNITY MEMBERS WHO WERE EAGERLY AWAITING THE ANNOUNCEMENT OF NKU'S FIFTH PRESIDENT. TERRY MANN, CHAIR OF THE NKU BOARD OF REGENTS, ANNOUNCED THE APPOINTMENT OF GEOFFREY S. MEARNS, AND THE AUDIENCE GAVE THE MEARNS FAMILY A PROLONGED STANDING OVATION. IN MAKING THE ANNOUNCEMENT, MANN STATED, "AFTER A LONG AND COMPREHENSIVE NATIONAL SEARCH, WE FEEL WE HAVE FOUND THE BEST PERSON IN THE NATION TO LEAD NKU."

by Gail Wells

at his installation as president: "I pledge that I will cherish the fundamental, human value of education and that I will put the interests of the institution and its people before my own self-interest. And I pledge to you that I will serve with courage—that I will do what is right, not what is expedient. I believe that, if we join together in this common commitment—to cherish the value of our educational mission and to put the interests of the institution before our own individual interests—then no financial constraint imposed upon us by Frankfort, no technological change, and no competitive threat will deter us. If we come together, then no external factor will prevent us from achieving our institutional aspirations or prevent us from realizing our own personal dreams. And together, together in service, we will transform this excellent university into an exceptional one."

Mearns had the unanimous support of the search committee and the Board of Regents. The university was confident it had found someone who could continue NKU's upward trajectory.

In coming to NKU, President Mearns was no stranger to the region. When he was growing up, his father had been law dean at the University of Cincinnati, and Mearns reported that he had "fond memories of running the hills on both sides of the Ohio River when [he] attended Walnut Hills High School." Mearns reported that he learned the value of education and the rewards of serving others from his parents. He was taught to put the common good before his own self-interest. He credits his parents for instilling in him the values that he communicated clearly in the speech he gave

Upon taking over the helm as president, Mearns was committed to both communities: the community of faculty, staff, and students internal to the university and the regional community surrounding NKU. To get to know them better, he held a listening tour that included twenty-three meetings with the internal community and later held twenty meetings with the external community. In addition, he e-mailed five open-ended questions to all faculty, staff, students, and graduates and many university friends. He received more than six hundred responses. What he learned convinced him of the strength of NKU and reassured him that he had made the right decision in accepting the presidency of the school.

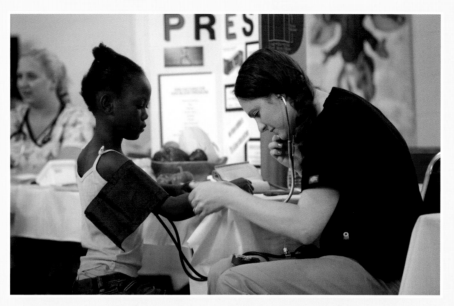

President Mearns switches jobs with a student, Colin Kremer, for a day; Mearns went to class while Kremer took over as university president, 2013.

A student performs community service work by giving checkups to children in Covington's City Heights neighborhood as part of the Nurse Advocacy Center for the Underserved Health Fair, 2013.

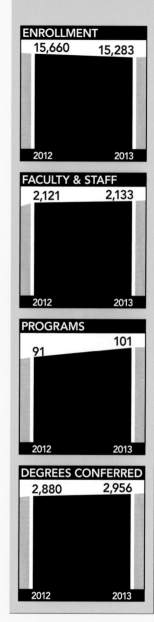

ENROLLMENT
15,660 15,283
2012 2013

FACULTY & STAFF
2,121 2,133
2012 2013

PROGRAMS
91 101
2012 2013

DEGREES CONFERRED
2,880 2,956
2012 2013

Following his listening tour, Mearns was ready to move the university forward. He began a strategic planning process. He created an eleven-person steering committee, the Strategic Planning Committee, composed of people internal and external to NKU, and, to show his commitment to the process, he personally chaired the committee. Seven work groups, each focused on a different aspect of planning, provided input to the committee. Eager to have a broad array of opinions, the committee held seven open forums for faculty and staff, three for students, twenty for external constituents, and one for alumni. In addition, an online survey sought comments from community stakeholders. The process was focused and intense and culminated with a strategic plan less than a year after the process began. The new strategic plan will guide the university through 2018, the university's fiftieth anniversary.

Mearns's commitment to students and their success was apparent from the day he arrived on campus. He and his wife, Jennifer, endowed a scholarship fund, named in honor of their parents. The scholarship provides support for first-generation college students committed to community service. He publicly and repeatedly stated, "Our single most important objective is the ongoing focus on student success," which he defined as "enrolling qualified students, retaining and graduating those students at high rates, and preparing those students to obtain meaningful employment as well as preparing them for a rewarding, fulfilling life." He not only gave verbal support to students, but also supported them through his actions: his administration continued support for the various offices and services that help students in their quest to be successful, and he personally connected with students by attending student athletic events and student performances, enjoying lunch with groups of students, and hosting dinners at his home for the Presidential Ambassadors, a group of outstanding undergraduate students who provide support throughout the year for campus events and activities. He also publicly recognized the critical role that faculty play in the success of students. Those who worked closely with Mearns said that he evaluated every one of his decisions in light of the effect it would have on students.

Mearns also continued NKU's commitment to the region. As he said at the 2013 Thoroughbred Awards Luncheon, "I pledge to you today that we will maintain our commitment to supporting the economic and cultural vitality of this region and our commonwealth." Not only did he include the community in his listening tour and in the strategic planning process, but he also included community members on the search committees he formed for hiring high-level administrators. Before his first year ended, he had accepted numerous

The Student Success Center, which brings together offices such as Career Services, the Veterans Resource Station, the Office of International Students & Scholars, Norse Advising, Student Wellness, Disability Services, Learning Assistance, and First-Year Programs, opened in 2013.

invitations to address community groups and five invitations to serve on community boards.

President Mearns expressed additional commitments during his first year. These included a commitment to high-quality undergraduate programs, graduate education, online programs, Division I athletics, professional development of faculty and staff, diversity, shared governance, and excellence in all that is done. He expressed great respect for the faculty, staff, and students who constitute NKU, and he committed himself to transparency and strong ethical values. He advocated for an institutional culture that is innovative, creative, responsive, and nimble. He believes strongly that good ideas can emanate from all parts of campus. As a testament to this, he created a $75,000 fund for campus improvement projects suggested and implemented by facilities staff members.

In concluding his first spring convocation, Mearns shared some of the history of NKU but then pointed out, "[Now] is our time to write the next chapter in the history of Northern Kentucky University." He encouraged people to embrace this responsibility with courage, humility, and excellence, and to work together with optimism and enthusiasm.

In 2014 President Mearns led a successful effort to obtain $97 million in state funding for NKU's Health Innovations Center, a project that also included the complete renovation of Founders Hall. The Health Innovations Center is designed to support an integrated portfolio of programs to prepare healthcare professionals, and to provide solutions to the region's health and wellness challenges.

Sounding prophetic in his fall 2012 convocation address, Mearns expressed his belief that the university's best days are ahead: "I am optimistic because of the quality and character of the people this university attracts and retains. As I have said before, our students are special—they come here with desire and determination, not a sense of entitlement. Our faculty and staff recognize that special character, and they reciprocate with their commitment to put the interests of our students and our university before their own self-interests. I admire you for that quality. As I continue to meet with people, and as I walk across campus, I also sense genuine enthusiasm and positive energy. I regularly hear people tell me that they are confident that our university's best days are still ahead of us. I share their confidence. I share their faith."

Gail Wells served as NKU vice president for academic affairs and provost for ten years. After thirty-four years at NKU, she is still giving to the university as a professor in the College of Informatics.

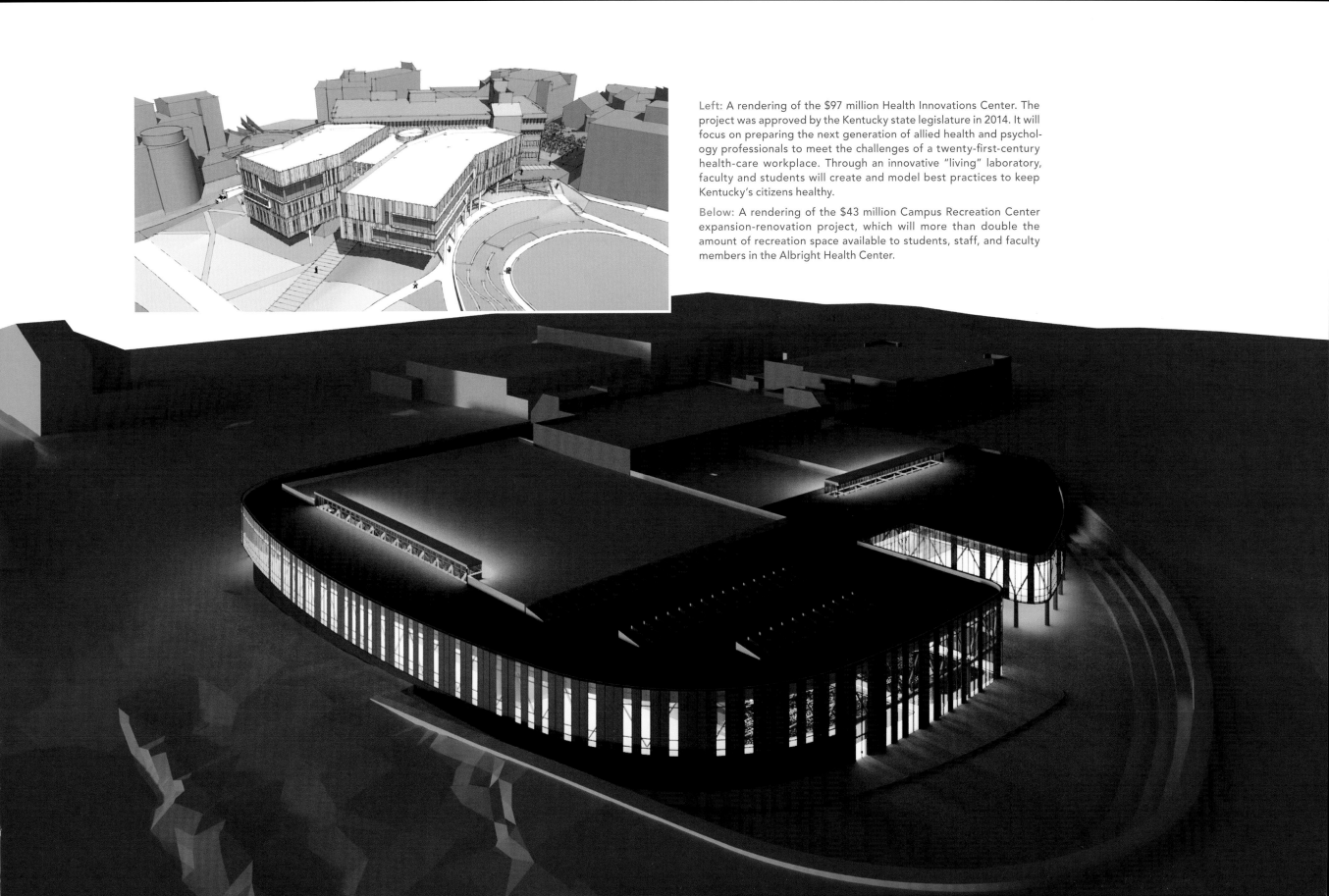

Left: A rendering of the $97 million Health Innovations Center. The project was approved by the Kentucky state legislature in 2014. It will focus on preparing the next generation of allied health and psychology professionals to meet the challenges of a twenty-first-century health-care workplace. Through an innovative "living" laboratory, faculty and students will create and model best practices to keep Kentucky's citizens healthy.

Below: A rendering of the $43 million Campus Recreation Center expansion-renovation project, which will more than double the amount of recreation space available to students, staff, and faculty members in the Albright Health Center.

Above: President Mearns in his office, 2014

Right: Lucas Administrative Center, 2013

KENNETH R. LUCAS ADMINISTRATIVE CENTER

The Lucas Administrative Center houses the university's executive offices and most university administrative offices, including registrar, admissions, bursar, and student financial assistance offices.

GROSS SQUARE FEET: 108,238 GROUNDBREAKING: October 18, 1979 ARCHITECT: Northern Kentucky Architects Consortium

ORIGINAL COST: $6,456,179 DEDICATED: July 15, 1982

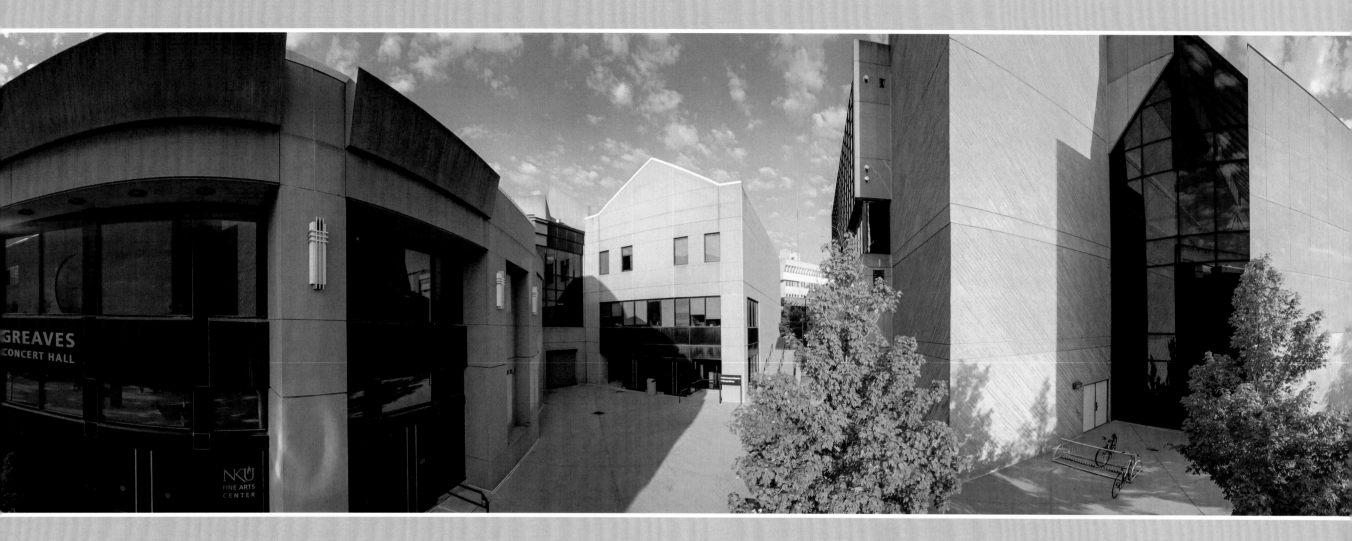

Above: NKU Corbett Theatre lobby, 2011

Left: Plaza between Greaves Concert Hall, Corbett Theatre, and Steely Library entrances, 2009

Above: Jazz ensemble concert in Regents Hall, 1978

Left: Band practice in the Fine Arts Center, 2009

Top right: Performance in Greaves Concert Hall, 2002

Bottom right: Symphony performance in Greaves Concert Hall, mid-1990s

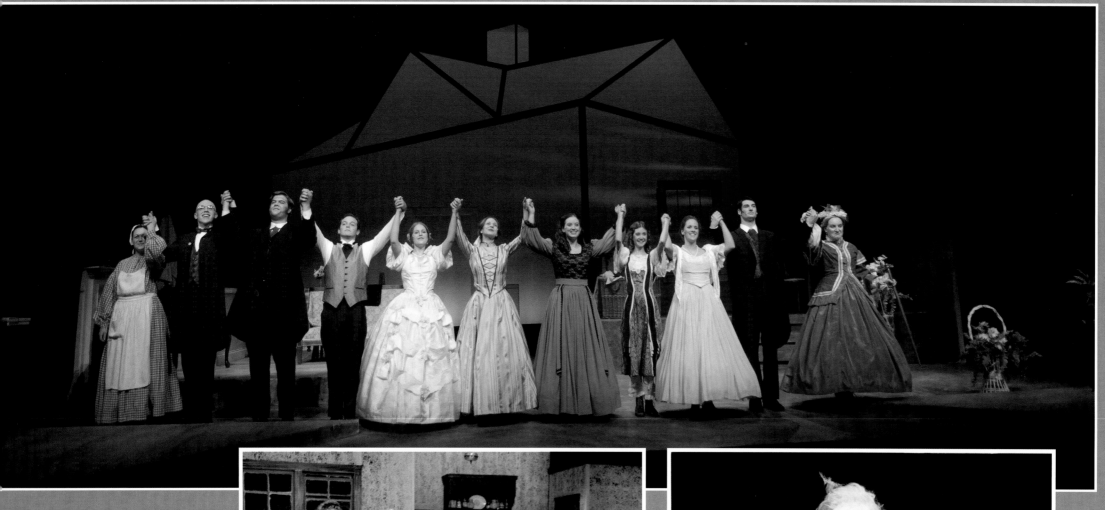

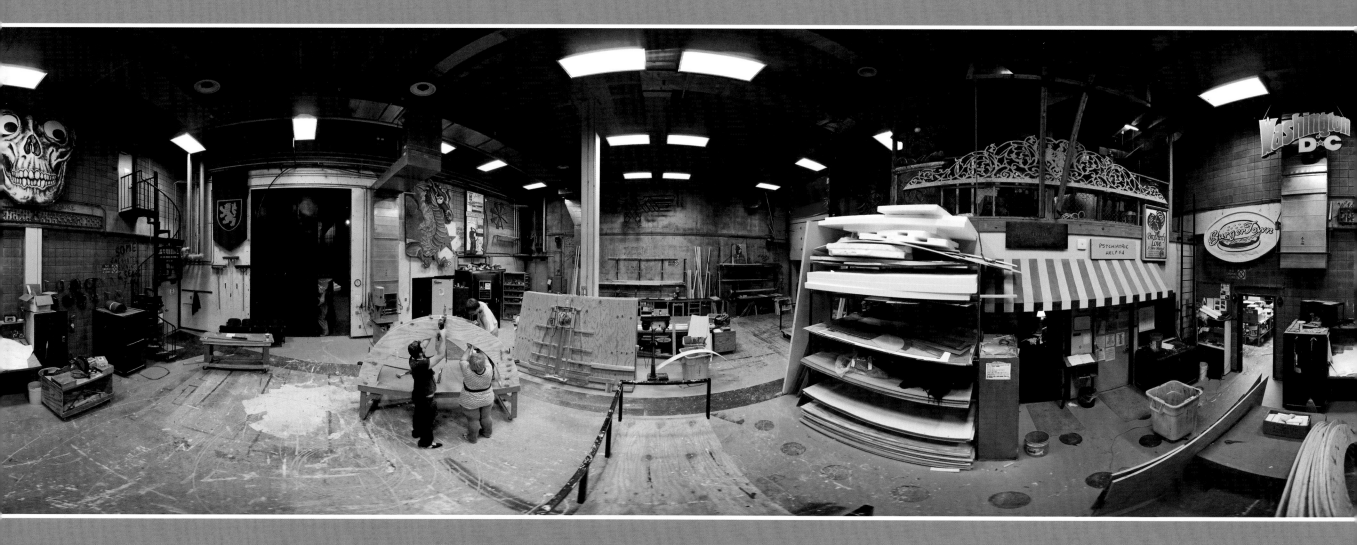

Above: Fine Arts Center theater shop, 2009

Previous page:

Top: NKU's theater students have produced some amazing performances in the Corbett Theatre, such as 2011's *Little Women*.

Bottom left: *Little Women* performance, 1991

Bottom right: Students shine in a performance of *She Stoops to Conquer*, 1993.

Above and left: Student events, like this concert in 2013, occur on a daily basis across the NKU campus.

Opposite page: President Mearns participated with students as they danced to the latest craze—the Harlem Shake, 2013.

Fraternity Bid Day, 2013

A student playing football on the NKU Plaza, 2009

Pumpkin bust, 2013

Color games, 2013

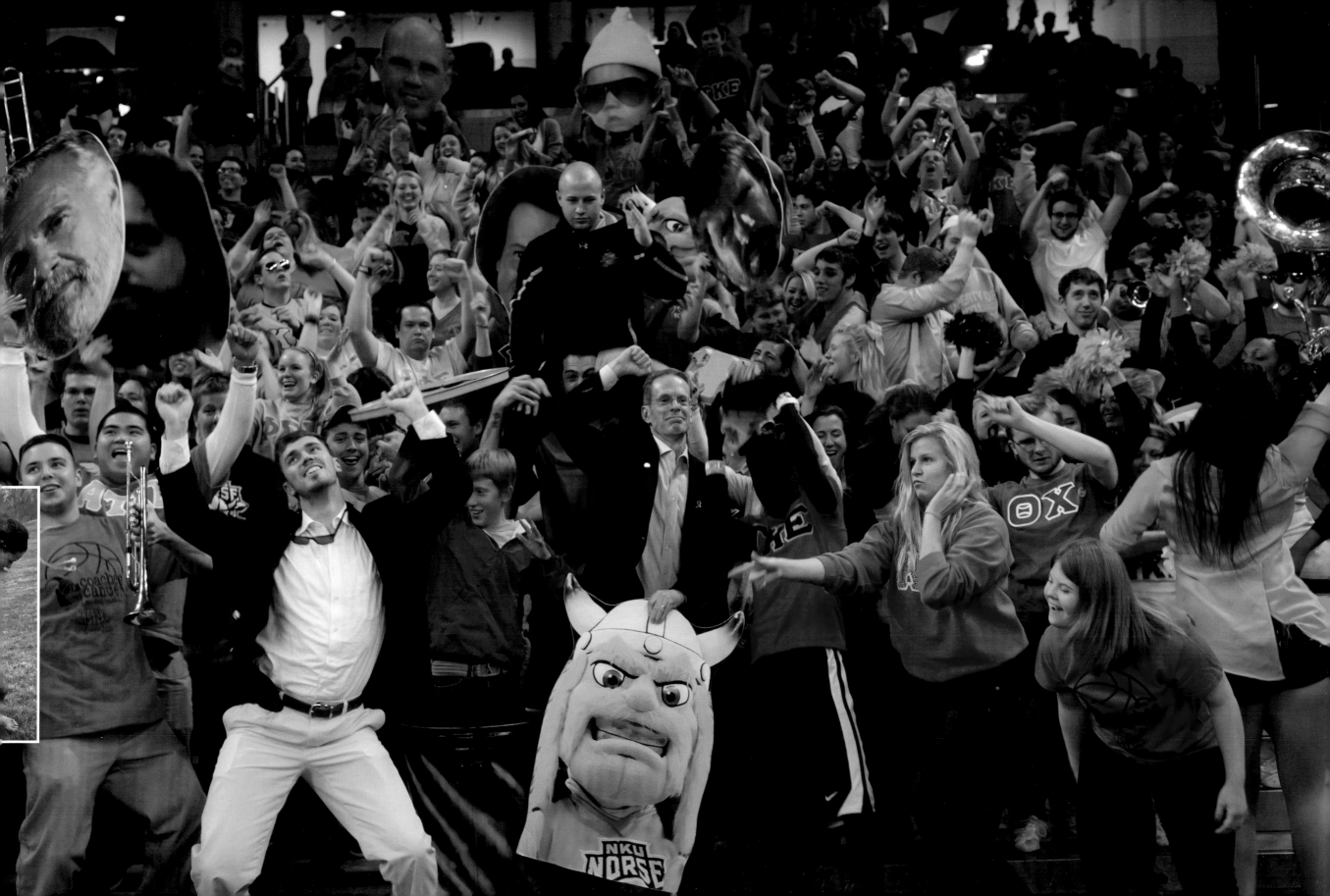

INDEX

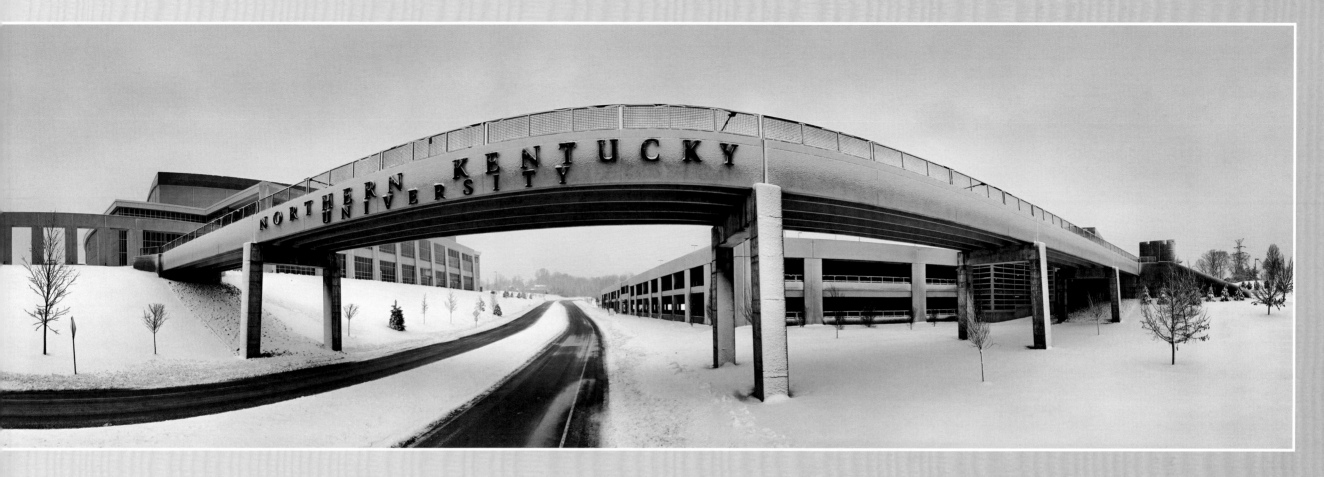

Walkway to the Bank of Kentucky Center, 2010

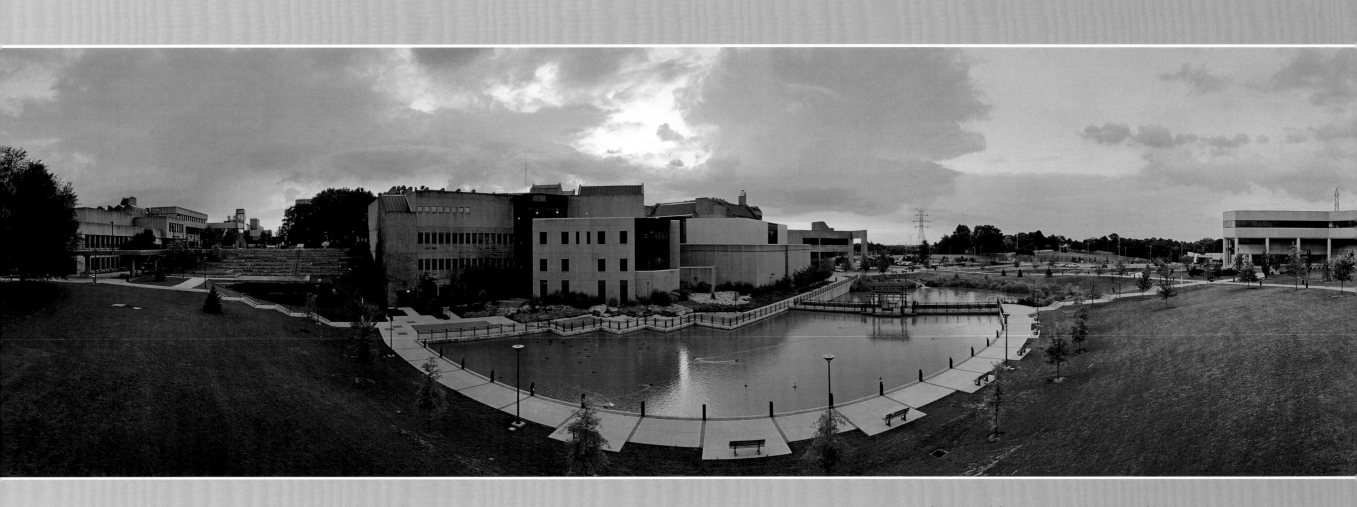

Loch Norse and the campus center at sunset, 2011